Remembering
ALAMANCE COUNTY

Remembering
ALAMANCE COUNTY

TALES OF RAILROADS, TEXTILES
AND BASEBALL

DON BOLDEN

Charleston ▯ London

History
PRESS

Published by The History Press
Charleston, SC 29403
www.historypress.net

Cover Image: A train with fifty-eight cars filled with furniture from White Furniture Company in Mebane is about to leave for Panama in 1906, loaded with furniture for the canal workers.

First published 2006
Manufactured in the United Kingdom
ISBN 1.59629.170.2

Library of Congress Cataloging-in-Publication Data
Bolden, Don.
Remembering Alamance County : tales of railroads, textiles, and baseball /Don Bolden.
 p. cm.
 ISBN 1-59629-170-2 (alk. paper)
 1. Alamance County (N.C.)--History--Anecdotes. 2. Alamance County
(N.C.)--Social life and customs--Anecdotes. I. Title.
 F262.A3B65 2006
 975.6'58--dc22
 2006021094

Notice: The information in this book is true and complete to the best of our knowledge. It is offered without guarantee on the part of the author or The History Press. The author and The History Press disclaim all liability in connection with the use of this book.

Contents

Introduction

Every passing day brings change not only to us as individuals but also to the communities in which we live. People come and go, businesses change, streets are rerouted and new housing developments cover land that once was wilderness.

Things of the past can disappear quickly, and in order to preserve some of these memories, books such as this one are produced. Alamance County is one of one hundred North Carolina counties, rich in a history that has affected the development of our state and nation.

I was born in this county, grew up here and have lived all my life here. I have long been fascinated with its past. For fifty-one years I wrote about the people, places and events in Alamance County in newspaper stories in my work with the *Times-News*. Along the way, I began to look at the past and wrote many articles on the county in a weekly history column. Over the years, I have written thousands of words on Alamance County's past, and the stories are no less exciting to me now than when I first started.

It was here in 1771 that a group of backcountry farmers—they were called Regulators—rose up against Great Britain's royal government in the Carolina colony, protesting the unfair taxation that crippled their ability to make a living. A battle occurred in May of that year near Great Alamance Creek in the area that would become Alamance County in 1849.

The independent and daring spirit of those farmers has continued to mark Alamance history as individuals dared to go into uncharted areas in business and industry, where people stepped to the front and provided leadership in the face of major challenge.

The county was born into a railroad heritage, but that evolved into textiles as the years passed, and Alamance County became one of the major hosiery and textile centers of the world. In later years, however, those industries declined as world conditions changed, and local eyes turned to other industries. Today, the Laboratory Corporation of America (LabCorp), one of the nation's largest medical testing laboratories, has its national headquarters in Burlington and is the county's largest employer.

The county's history has been marked by continuing change, and its people have adapted well.

In the pages that follow, there are stories about the people, places and events that have helped shape Alamance County history. The stories and photos have been collected over a long period of years, and they are but a sampling of things that have given Alamance County a special place in history. Some of these stories appear as they were written years ago and have appeared in other publications, others have been revised, while others were written particularly for this book. Together, they give a quick glimpse of Alamance County and its most interesting past.

The photos come from the author's personal collection unless otherwise indicated.

Company Shops

Burlington, North Carolina, is a city known the world over as the birthplace of what once was the largest maker of textile products in the world.

Burlington Industries, of course, brought much recognition to this city, and rightfully so. The city, North Carolina's seventeenth largest in 2000 with 45,000 people, certainly found its place in history with the many textile operations that were located here for so many years.

Hosiery was a major component of the industrial makeup of the city for decades, and at one time Burlington was advertised as "The Hosiery Center of the South." There were scores of hosiery mills, big and small. There were the major producers, such as Kayser-Roth, May-McEwen-Kayser and Burlington Industries. And there were the smaller family operations, such as Foster Hosiery, Elder Hosiery and others.

With that background, many are surprised to learn that Burlington was born not as a textile center but as a railroad town, not known as Burlington but by the generic-sounding name Company Shops.

The North Carolina Railroad built a maintenance facility in the mid-1850s on the site that today would be downtown Burlington.

There is an interesting story in the way this particular site was chosen for the railroad shops. For the entire picture one needs to go back to 1848. The North Carolina General Assembly approved legislation to charter the North Carolina Railroad. The plan was to run a rail line from Goldsboro in eastern North Carolina to Charlotte in the west. This would provide a new and more efficient means to move agricultural goods and other commerce about the state and would allow passenger travel as well.

This action occurred a year before the new county of Alamance was formed almost in the center of the state—almost halfway between Goldsboro and Charlotte.

Once the railroad was established by law, the next move was to determine where the tracks would run. One plan would have taken them across the southern Piedmont area on a relatively direct line between the two terminals. But there were those in the new county who badly wanted the rail line to come through Alamance. Giles Mebane was representing Alamance in the legislature at the time, and he had been the one who pushed the legislation to establish the county. Mebane worked hard to get the rail line in his direction. He got help from some of the businessmen in the county as well. General Benjamin Trollinger at Haw River offered to build bridges for the line over Back Creek and Haw River. He wanted to build a hotel at Haw River and wanted the tracks to run there. Others offered help by actually building some of the tracks.

Their efforts paid off, as the railroad's board chose a route that passed directly across Alamance County almost in a straight line, east to west. Part of the plan also included the location of the maintenance and repair facilities that would be needed to build engines and railroad cars and to keep them running.

The spot wanted by railroad directors lay at Glen Raven, a site just west of what is now downtown Burlington. However, no agreement could be reached with the owners. The railroad then decided the best spot would be at Graham, a plot of land that had been purchased as near as possible to the center of the county to be the site of courts and county offices.

The railroad company decided to build its tracks about a block north of the new courthouse, then build the maintenance facilities just on the edge of the town. One might think Graham residents would have been enthused to have this big industry and its jobs as a part of their community. This was hardly the case: They wanted no part of the smoke and the noise and passing trains. They feared the courts would be disrupted by the noise, and they felt pedestrians and horses and other livestock would be in danger. The decision was made to keep the railroad out, and an ordinance was passed that prohibited a railroad or any railroad shops within a mile of the courthouse.

Officials of the railroad decided they were not welcome in Alamance, so they decided to look for property in Greensboro, twenty-five miles to the west. Before that could happen, however, General Benjamin Trollinger—the same man who built the bridges earlier—suggested a site two miles west of Graham. He owned land there, offered it to the rail line and even helped raise money for the purchase price. The railroad bought 632½ acres for $6,748.37. Land from four other owners was joined to that of Trollinger in the sale.

In raising the money, Trollinger even went to some of the early merchants in Graham, and they contributed. But they did so only after asking for an agreement that

no businesses would be erected in the village of Company Shops. Such an agreement was actually signed, but Walter Whitaker's *Centennial History of Alamance County* notes that it was never recorded, and it "disappeared mysteriously a short time afterwards."

The land was purchased in 1854, but it was two years more before the first building was completed, a boardinghouse owned by James Dixon. The first business operation was Jonathan Worth and Company, and it included a general store, the railroad station and a post office. There was a Masonic hall on the second floor that also served as a place of worship. The railroad erected seven shop buildings: a locomotive repair shop, a foundry, blacksmith shop, a wood shop, an engine shed and two car sheds. Eight small brick houses were built for mechanics and company officials. There was one large brick building constructed next to the tracks, which would serve as the offices of the North Carolina Railroad Company.

As these buildings were completed, another structure, the Railroad Hotel, was built next to the tracks. This was a large structure of brick and wood, and it had two stories as well as a huge veranda that extended around all sides. It was a beautiful building, and it would become a popular spot for tourists and locals alike. As passenger trains approached, they would telegraph ahead with the number of people aboard, and a stop would be made for twenty minutes for a meal in the hotel dining room. Freight crews always made the hotel restaurant a stop as well.

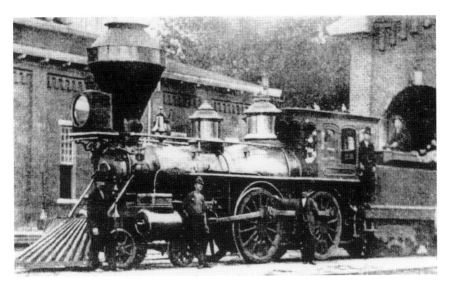

An engine of the North Carolina Railroad stands outside the engine house in the village of Company Shops, circa 1880.

The little community that was beginning to grow would be known simply as Company Shops. It was not until 1866 that the town was actually incorporated, however. The village grew to include almost thirty buildings, and the shops employed thirty-nine white men, two free blacks and twenty slaves.

The shops were an active place, as the railroad company had considerable rolling stock. There were six passenger engines, eight freight engines and two gravel locomotives. It also operated eighty-two boxcars and eighty-six cars of other types, including those for passenger use.

By 1864 there were three hundred people in Company Shops, and with a number of new buildings, the community saw need to purchase its first fire engine. Two years later, when Company Shops was incorporated, it was one and a half square miles with the hotel as the central point.

A little known part of the history of Company Shops was discovered a few years ago by a Burlington attorney, W. Clary Holt, whose wife Bea was for many years a state legislator for Alamance County. Holt was an avid stamp collector, and through that hobby, he discovered that the name of Company Shops had at one time been changed to Vance. He once found an envelope postmarked in Vance but could find no record of such a place in Alamance County. Years later Holt read in *The History of the North Carolina Railroad 1849–1871: The Modernization of North Carolina* that there indeed was a Vance, North Carolina.

The book's author, Dr. Allen N. Trelease, professor of history at University of North Carolina, Greensboro, noted that in 1863 eight members of the board of directors of the railroad had been appointed by the new governor, Zebulon Vance. Because some of the families in Company Shops wanted a less generic name and in response to the governor's kindness, they changed the name to Vance in October 1863. In July of 1864, the stockholders met and changed the name back to Company Shops. Why? Holt noted that Governor Vance was a Democrat, and the majority of the stockholders were members of the Republican Party. Also, another post office in the state had the name Vance, so the change was appropriate.

The War Between the States had major impact on the entire area, but Alamance County was spared the fighting that hit other areas. However, there was a significant event in Company Shops as the war wound down. In 1865, Yankee General William T. Sherman was marching north, nearing Raleigh. Confederates were surrendering all along the way. As Sherman's force came near, General Joseph Johnston gathered his remaining troops in Company Shops near the depot,

told them farewell and sent them home. He then walked to the depot where he boarded a train with a single car. Captain W.H. Turrentine of Company Shops was the engineer that day, and he drove the train to a site near Durham where Johnston surrendered to Sherman.

Company Shops was a center of major activity for many years, and the population increased as time passed.

The workers' children needed education, and the railroad company built a large-frame, two-story building on the north side of the tracks. During the week it was Union School for every student in the community, while on Sunday it was Union Church. There were general services open to all, but there was also time given to various denominations so they could have their own services on a regular basis: Methodists, Episcopalians, Baptists, Lutherans and Presbyterians all met at Union Church.

Toward the end of the century, however, membership in the various denominations had grown to the point that they began, one by one, to move out into the community and build their own worship sites. The old school remained in use until the first decade of the twentieth century when the public school system opened facilities in the town.

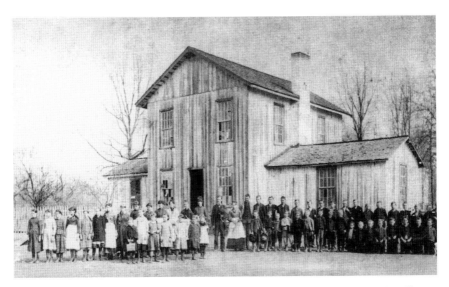

This old frame building was erected by the North Carolina Railroad Company in the village of Company Shops to serve as both a school and a church for village residents. It was known as Union School and Union Church.

Company Shops continued to prosper for many years, but then in 1886, changes were made in the railroad operations and it was announced that the shops would be moved to Manchester, Virginia. About 1890, however, the local shops were reopened while the railroad looked for a larger site Finally, in 1897 all operations were moved from here to Spencer, North Carolina, where much larger facilities were built to better serve the growing needs of the railroad.

When the railroad left, many wondered what would happen to the little town of Company Shops. It did not, as some feared, fade into history. A new name was found and new industry filled the gap left behind: just a hint of it came when a small factory opened under the name Daisy Hosiery Mill.

Hosiery? A new era was born.

When the railroad moved away, a new name was chosen for the town. It became Burlington in 1887. Other companies moved in and used some of the old shop buildings. For a time, a company used one of the former railroad buildings to make steel structures for bridges, but as the years passed the images of Company Shops and the old railroad faded.

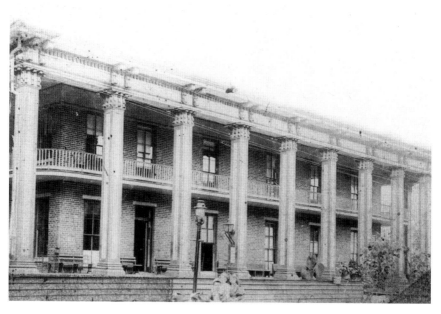

The Railroad Hotel was built soon after railroad operations began at Company Shops. It served those who traveled along the rail line, and its restaurant served both passengers and residents of the community alike.

The old hotel operated until just after the turn of the century, but it was destroyed in a spectacular fire. A disgruntled employee who had been fired is said to have torched the building one night, and by morning only a shell remained.

One of the buildings, the engine house, has remained continually in use. It was for many years home of a plumbing supply company, but just when it appeared that it might be demolished, the North Carolina Railroad refurbished it and made it Burlington's new depot early in the twenty-first century. The building also houses a display of railroad history, with a complete model of the old village of Company Shops and a huge collection of photos. There are also full-sized replicas of two engines coming from the wall: one, an engine from the Company Shops era; the other, a modern diesel.

The building housing the depot and display is believed to be the oldest railroad building still standing along the entire line. It was built around 1856.

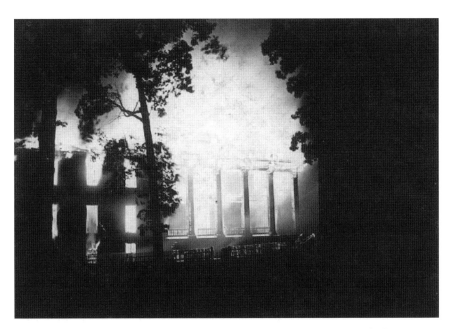

The old Railroad Hotel was destroyed by fire in May 1904, and it was never rebuilt.

Early Businesses in Burlington

Names of huge national chain retail stores are seen in a growing number of shopping centers across Alamance County today, some of them huge megastores that contain tens of thousands of feet of floor space. They are the same stores one sees in South Carolina or New York or Minnesota, the stores that have transformed the way America shops.

These retail behemoths are relatively new to the business community, appearing in growing numbers as the twentieth century moved toward its end. Before the Wal-Marts and Targets appeared, there were family businesses, owned and operated by members of the communities in which they did business. Some of them were long fixed in the retail community, while others came and went as times changed.

While Burlington was still known as Company Shops, two families began small operations, which would still be in business one hundred years later when those big national chains began to appear.

There wasn't too much here in the 1870s. Company Shops was not only the name of the town, it was also the industry: the repair and maintenance shops of the North Carolina Railroad. Naturally as people came here to work, they had to have stores where they could fill their needs. There was an early dry goods store, and as time passed other small businesses opened.

C.F. Neese opened a small jewelry operation in 1870. He first started in a tent, but later moved to a couple of locations before finding his way to a key location at the corner of Main and Davis Streets. It would remain there for more than a century. That store gave Burlington one of its most colorful characters in 1887 when C.F. "Pete" Neese was born in the family quarters above the store. The first C.F. Neese was always known that way, as C.F. Neese. The second was named Freeman Neese and took the letter C for a first initial, although it stood for no name. He would always be known as Pete.

C.F. "Pete" Neese is shown in Neese Jewelers, the store his father opened in 1870. Pete was born upstairs over the store in 1887, becoming the first child to be born in the newly named town of Burlington.

It turns out that Pete could lay claim to having been the first child born in the town of Burlington. It was in early 1887 that the name of Company Shops was changed to Burlington, and Pete was born a month later, the first in the town with a new name.

Pete spent all his life in that store. In fact, he claimed he was born upstairs over the store one day, and the next day he was downstairs working. That was not too far off, really, as his parents took him downstairs with them often while they worked, and he indeed grew up in the family store. He took up operation of the store on the death of his father in 1912, and he would be joined later by his son, C.F. Neese Jr. A member of the family's fourth generation, Jack Neese, would be a part of the store later.

Dr. B.A. Sellars, one of the few physicians in the community, opened a small mercantile establishment in 1872. It was the first department store operation in Company Shops. The store was first located on Front Street and had about 2,500 square feet of floor space. It opened with three employees.

Lighted by kerosene lamps, the store was an exciting place for Company Shops residents, especially the ladies who had to take care of clothing a family. This new store offered new materials from which they could make clothing. Sellars was one of the first to offer ready-to-wear garments when they arrived a few years later. That little store was also believed to have been the first in Alamance County to have women employed as clerks. In 1900 Miss Amelia Burch took her place behind

the counter to serve customers there, even though women had not been considered for such work in the past.

Within a few years, the store moved its operations to a larger site on Main Street, opposite and just up the street from Neese Jewelers. The kerosene lamps were replaced by the more modern acetylene gaslights coming into use at the time.

Another female employee was added then, Miss Nerta Holt. Miss Holt worked in the business office, apparently the first woman to work in the business operation of any such store in the area. She did her work without any of the mechanical equipment later associated with such offices. Sellars, however, was one of the first in the area to have a typewriter. It had two keyboards: one for small letters, and one for capitals.

An advertisement from Sellars in 1889 listed the following: "Large lot of ready made clothing for men, youths and boys from $1.25 per suit up...a large lot of ladies dress goods, trimmings etc., hats etc., pant goods, shoes, all of which will be sold at and below the same price of those that are 'selling out at cost'...see for yourselves."

In 1893, still another ad for suits read: "The blue black and fancy cheviots are having quite a run now. They come in sacks, single and double breasted at $6, $7.25, $10 and up."

The little department store grew over the years, and it later became B.A. Sellars & Sons. The size of the store was expanded several times over, and eventually it

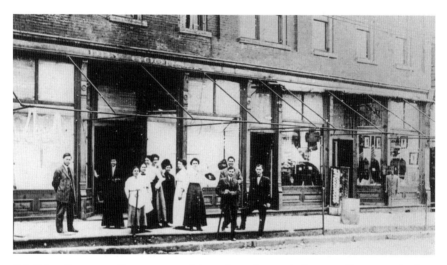

B.A. Sellars Department Store was one of the early retail stores in Company Shops, opening in the early 1870s. This photo of the storefront and employees was taken in 1909.

came to have entrances on three downtown streets. It was the leading department store in the area.

As the years passed, both the Neese and Sellars operations looked out on a constantly evolving business area. Stores came and went, and during the 1940s and 1950s, downtown Burlington was a thriving, bustling business area.

Then in 1963 came a new term: shopping center. That was a place where several businesses were grouped together, usually under a single roof. There was plenty of unlimited parking at the front doors of those businesses with no meters to take one's nickels and dimes. The first shopping center in Alamance County was east of downtown Burlington, and while most of its occupants were new stores, one was from the downtown business area. Rose's 5&10 Store moved out of its longtime location and opened in the new shopping center, Cum-Park Plaza. Rose's had been a fixture downtown, visible on three streets. When it moved out, the Sellars operation took over some of its floor space and expanded.

There were more to come, however. Or, truthfully, more to go. In 1969, the area's first shopping mall, Holly Hill Mall, opened west of Burlington. This was a major facility, a little city within itself, all under one roof with all the stores opening on the interior mall area.

The anchor stores in the mall were Sears, Woolworth 5&10, Belk-Beck Department Store and J.C. Penney. Each opened major stores in the mall—as each closed major stores in downtown Burlington. That initiated a decline in the downtown area that would extend over a long period of years. Redevelopment was attempted, and blocks of buildings were torn down. A couple of major banking facilities were constructed, and for a while Main Street was actually closed off to create an open mall to better attract shoppers. That did not work, and the street eventually was reopened.

Eventually, Sellars felt the loss of shoppers strongly enough to shut its doors downtown and move to a much smaller shop near Holly Hill Mall. Neese Jewelers eventually was sold, and a few years later it too closed its doors.

One wonders what might have happened to the area had it not been for a relatively new resident of downtown.

Dr. Jim Powell had formed a small medical testing laboratory in Burlington some years in the past. That firm, Biomedical Laboratories, later became part of Roche Biomedical, and eventually part of the Laboratory Corporation of America (LabCorp).

Under Dr. Powell's guidance, LabCorp began buying buildings in the downtown area and putting company operations there. One after the other, buildings became

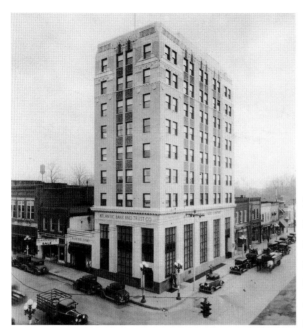

This building, Burlington's tallest, was built in 1929 as the home of Atlantic Bank and Trust Company. Upper floors were occupied by doctors, lawyers and dentists for many years.

part of the LabCorp campus. Several were important to Burlington's history, none more so than the old Atlantic Bank and Trust Company tower, a nine-story building that was built in 1929 and remains the city's tallest.

The tower had housed several banking operations over the years, and upper floors had been offices for the medical and legal community. Vacant for a short while, its future was in doubt when LabCorp purchased it. A complete renovation was made of the structure, and one floor was redone as it was first constructed. Original architectural drawings for the building are framed for visitors to see on that floor.

LabCorp also bought the old Federal Building downtown, a unit built as a post office in one of the government's Depression-era recovery programs. Today, that building is the national headquarters for LabCorp, one of the leading medical testing facilities in the United States.

There remain many local business operations in Alamance County today, but they share the space with the huge box megastores now. The days of Sellars and Neese Jewelers have long since passed, but those stores and the others like them were a part of Americana that lives on in the history of every community in the nation.

Mill Villages in Alamance

Alamance County and Burlington enjoyed a great surge in textile development in the nineteenth and early twentieth centuries. Numerous cotton mills came into existence, first along the banks of the Haw River and Great Alamance Creek, and later after the development of steam power plants, in the towns of Burlington and Graham.

There had to be power to operate the looms, and in the early years such power had to come from water. So, mills were often located in remote rural areas on the banks of a stream. The water was dammed and diverted through a race into the mills, where it turned wheels to generate power. This location issue created a major problem: there was no transportation available to move workers to the mills. The workers would have to live within walking distance.

That gave birth to the mill villages across this county. Several Alamance County communities were born as mill villages. When a textile plant was constructed, the mill owners built houses around it for the workers, and they also built a company store. Everything the workers and their families needed had to be provided.

A horse and buggy was the main mode of travel then, and roads left much to be desired. Usually a family would leave the mill village for a visit in a nearby town maybe twice a year. Such a trip was quite difficult for them. Therefore the mill owners constructed rows of houses as close to the mill as possible and rented them to the workers. The rent was taken out of their pay.

The typical mill house was of frame construction, from three to eight rooms. The framing rested on joists, and the joists on brick pillars. There was no underpinning and air circulated beneath the house. Flooring was four-inch boards, the ceilings and walls were finished with beaded molding and there was usually tin on the roof. Doors were solid and windows were usually six panes. The upper sash of a window

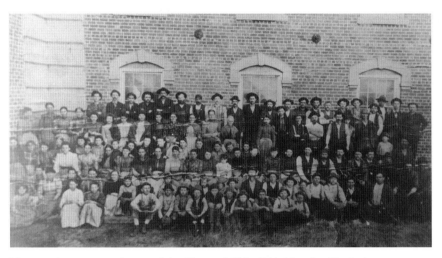

These workers were employees of the Glencoe Mill in 1913. Most lived in the houses provided by the mill, just up the hill from the company store.

was fixed in place and could not be opened. If you raised the lower sash, you had to prop it with a stick because there were no weights in the window frames.

The larger houses were two stories with a stairway in the hall. At the rear of the house was a pantry or larder for storing foods. These larger houses sometimes were boardinghouses where unmarried workers lived. Lots usually were fifty feet wide by seventy-five to one hundred feet deep. There was no indoor plumbing, of course, so outhouses were built on the back of the lots. There was no running water either, so wells had to be used. Ordinarily, one well was dug to serve six to eight houses, and sometimes it would be covered with a small roof. Needless to say, the use of either the outhouse or the well could be quite uncomfortable in times of bad weather.

There were narrow streets in the village, and they usually were in one of two conditions: very dusty or very muddy. Each village had its own church, and most had a school as well, often no more than one or perhaps two rooms. The center of each village was the company store, a general merchandise store where the mill family could purchase its needs. At one time, some of the mills paid their workers partially in merchandise from the company store, but the state later passed legislation to prohibit this practice.

There were many such villages across Alamance County—Bellemont, Alamance, Saxapahaw, Swepsonville, Haw River, Hopedale, Glencoe, Altamahaw and Ossipee—and in Burlington there were several neighborhoods built as mill villages around textile

The houses along this road were built for workers at the mill at Bellemont in Alamance County. This mill village is now on the National Register of Historic Places.

plants that opened in the latter part of the nineteenth century. Even Burlington Mills, formed in 1923, had its own mill village of company-owned houses.

One of the early mills that opened was in a community at one time known as Lambert's Mill. It became Altamahaw near the end of the nineteenth century. Around 1870 John Q. Gant Sr. and Berry Davidson bought a grist mill in the area. The two decided to build a textile mill there in 1880, and in 1883 a business guide noted that the major industry in the community was Davidson and Gant, operators of a general store and makers of cotton warps. Davidson soon sold his interest, and Lawrence Holt and L. Banks Holt joined the operation, now called Holt, Gant, and Holt.

John Q. Gant was something of an innovator. He was one of the first in the area to have a telephone system connecting his plants, and his wife had one of the first autos in the area. The cotton mill he helped found at Altamahaw continued to operate until it shut down briefly in the Depression. In 1933 Allen and Roger Gant reopened the mill as a silk operation. That firm today is known as Glen Raven Mills, and it celebrated its 125th anniversary in 2005. Glen Raven is known the world over for its awning fabrics and other special materials. At one time, the company was a major presence in the hosiery industry. Pantyhose were developed in Glen Raven, a move that transformed the entire hosiery industry as well as the fashion world.

The old mill village began to fade in the years after the automobile came into wide use. When it reached the point when people had ways to get to work other

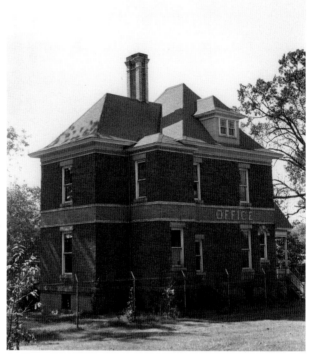

Glen Raven Mills has been in Alamance County for more than 125 years. This was the office building constructed when its operations were in the mill community of Altamahaw.

than walking, the mills decided to sell off the houses. Many workers purchased their houses directly from the mills. It was then that houses began to take a different look as the working families took pride in ownership and customized their houses to fit their own particular needs.

With advantages in transportation, people began to drive to work or ride the streetcar, and later bus service became available. When that happened, life in the county began to take on a different character. No longer were people confined to one particular area by necessity. Many became commuters and a part of Alamance County's history faded into the past.

One such mill village in Alamance County, Glencoe, is being brought back to life. The old houses, vacant for many years, are being restored, and families have moved into several of them. The old company store is now the Textile Heritage Museum, which is being developed to portray the history of the industry in both Alamance County and North Carolina. The old mill is to be developed into condos and businesses. Glencoe is one of the few mill villages remaining in much the state it was in when the mill closed in the latter part of the twentieth century.

Recreation in Nineteenth-Century Alamance

Imagine no movies to attend and no radio nor television. How would you exist? What would you do for entertainment, for recreation? No computer games? No City Park with all its rides?

Life would be really boring!

Residents of Alamance County who lived at the end of the nineteenth century would have told you otherwise. It seems they found plenty to do and were hardly bored. People had their sports events even then, and there were community and cultural gatherings to consume the time one might spend now with a movie or television.

In the sports area, men enjoyed hunting and fishing, and just as today, there were turkey shoots in which marksmen showed their skills. Baseball was coming into its own in the late 1800s in Alamance County, and each community had its own team, forming pretty keen rivalries even in those days. However, the baseball skills we know today were not quite so refined in 1887 if we take one recorded score as an example: the Graham Mutuals defeated a team from Company Shops by a score of 41–38.

Wrestling and boxing were big sports at that time, as were high jumping and broad jumping. Pitching horseshoes was a popular way of enjoying one's leisure hours toward the turn of the century.

Of course, this was before the automobile, and the advent of auto racing was still years in the future, but races were popular just the same, with contestants racing horses or horse and wagon teams.

There were some in the county who owned prize racehorses. One of the most famous was a horse named John R. Gentry, owned by L. Banks Holt of Graham. In 1894 John R. Gentry was entered in a race in Terre Haute,

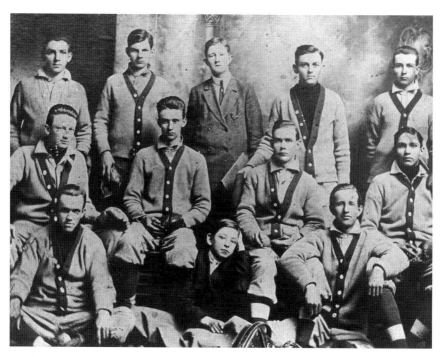

This baseball team represented a school in Burlington as the nineteenth century evolved into the twentieth. There were many such teams across the county, as baseball was one of the favorite activities of the period.

Indiana. The horse was a pacer, and in that race he stepped off a mile in 2.03 minutes—a world record for pacing stallions. Another famous horse of the day was Espranza, owned by Colonel Julius Harden, also of Graham.

One of the largest local annual events had its beginning in 1888. In that year the first county fair was held in a warehouse on Davis Street in Burlington on October 10 and 11. It was a success, and in the same year, the fair association signed a thirty-year lease for twelve acres of land to be used in the future as fairgrounds. That site was near what would later be a Burlington Industries plant on Anthony Street, and it gave Burlington such street names as Fair Street and Race Street, so named because of the fairgrounds' racetrack.

The fair was a big event, and people came from long distances to take part in activities and to listen to the speeches. There was a long table inside the racetrack on which picnic lunches were spread.

Tales of Railroads, Textiles and Baseball

Those were the days when men in the county would get together for barn raisings and corn shuckings, and the ladies enjoyed such things as croquet, spelling bees and quilting parties. When there was a barn to be raised or corn to be shucked, all the neighbors would come together to share in the work. While the men built the barn or worked on the corn crop, the women would quilt until it was time for lunch. They would then spread a meal to serve the big appetites of the working men.

For teenage boys of the day, one of the favorite spots was the Company Pond, which was located in the area of Burlington's City Park today. The pond furnished water that the railroad needed for its engines at the uptown shops area. The water was pumped from the pond to the depot. This pond also served the town's first firefighting equipment. Pipes were laid from the pond to the first hydrants in town to offer fire protection.

For the family who wanted to dine outside the home in those days, there were not many places to go. For most people, eating out meant having a picnic or dining at some special event. There was, however, one restaurant in Burlington at the Railroad Hotel. The food was famous all along the line, and train crews would telegraph ahead to make reservations for passengers. They joined the local residents who went there to feast on the quail, turkey and chicken featured on the menu. They might find themselves eating alongside someone famous as well: among the people who stopped at the hotel, according to local stories, were Thomas Edison and Henry Ford.

Although the people who lived here at the turn of the century did not enjoy the luxuries of entertainment we have today, there was plenty to keep them occupied—it could have been a horse race, a baseball game or a buggy ride in the country—and they were never at a loss for something to do.

Furniture for the Canal Zone

In 1906 work was still underway on the Panama Canal, but that was happening a long way from Alamance County. What possible connection could there be between that effort to link the Pacific Ocean with the Atlantic and the small community of Mebane in eastern Alamance?

For many years the photo hanging in the office of White Furniture Company in Mebane revealed the answer to that question (although it has since been moved to Mebane's historical museum). The huge mural shows a train sitting on the tracks in Mebane, with fifty-eight freight cars attached to the engine. It is bound for Panama, loaded with furniture to be used by the men building the canal. All the furniture was manufactured in the White Furniture plant, located right by the railroad line.

Some histories tell us that Stephen A. White was the first person to settle in what would be Mebane. He and others who followed were attracted to the area by news that the North Carolina Railroad Company was going to build a railroad through the county.

White's name would be linked to Mebane's history in ways other than as the first settler. In 1881 when the town of Mebanesville (later shortened to Mebane) was incorporated, White was the first mayor. In that same year, he and his brother, D.A. White, and a third partner formed White Brothers Furniture Company. Each man put up $350 in capital to purchase a planer and a carload of lumber.

The company first built window sashes and doors for construction of new buildings. In 1896 the company began to manufacture furniture for the first time, and from that point White Furniture Company moved on to become one of the major furniture makers in the South.

Another company linked to the needs of the home came when the Mebane-Royal Company began operations. That firm made mattresses under a name now known all over the world: Kingsdown. There were a number of other major industries over

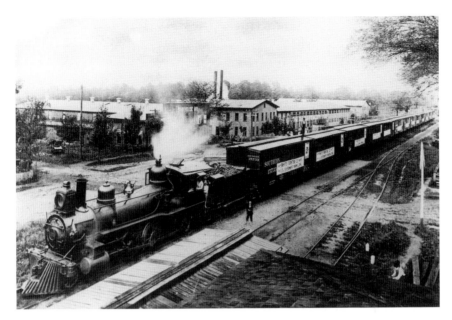

A train of fifty-eight cars loaded with furniture made by White Furniture Company in Mebane left for the Panama Canal Zone in 1906. The furniture was to be used by the men who were building the canal.

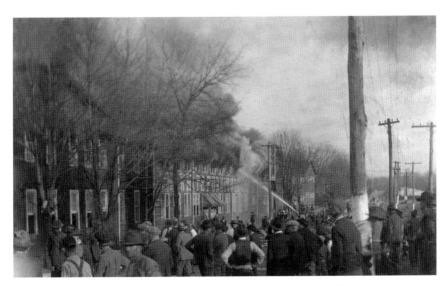

A massive fire hit the White Furniture Company plant early in the twentieth century, but the company rebuilt the damaged areas and continued as one of Alamance County's major industries for many years.

the years, including textile mills, hosiery makers and others. Toward the end of the twentieth century, a new influx of industry came into the area that was marked by a diverse group of operations not connected to those of the past.

One of the biggest stories of the late twentieth century concerning industry in the Mebane area was about an industry that did not ever arrive. Mercedes, the German auto firm, was looking for a plant location in the United States, and a plot of land just south of Mebane was one of the locations under consideration. That generated huge excitement throughout the area. As time for an announcement neared, it appeared that Mebane would be the site of the new plant. However, at the very last minute, Mercedes, lured by a massive package of incentives, announced that the plant would be built in Alabama.

Still, Mebane enjoyed phenomenal growth caused much in part by its proximity to the Research Triangle in the Raleigh-Durham area. Many people who worked in that area moved into Mebane, and that spurred the growth at a rapid pace. Mebane was one of the fastest growing communities in the state at the end of the century.

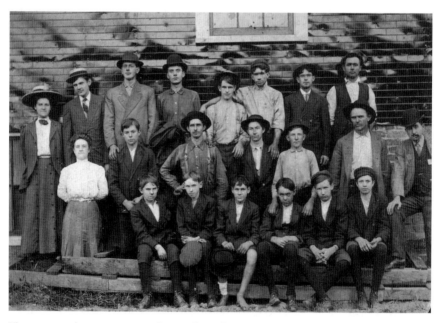

These men and women were workers at the Mebane-Royal Company in Mebane early in the twentieth century. That company later became Kingsdown, one of the major mattress makers in the United States.

Streetcars Change a County

When streetcars are mentioned in Alamance County today, many people draw a blank. Modern-day residents of this area do not recall any such vehicles in the county's past, as they were here many years ago.

The electrically powered vehicles were operated for more than a decade by the Piedmont Electric Company to link three communities: Burlington, Haw River and Graham, the county seat. The streetcar line provided the first type of public transportation in the area, bringing commuting to the local community. For the first time an individual could live in one part of Alamance County and work in another. Before the streetcars, most people had to walk to their jobs, as only the very wealthy were able to afford automobiles. The streetcars operated from 1911 until 1923, when automobiles and buses replaced them as the favored modes of transportation in Alamance County.

The new transportation service made it possible for people in one community to go to another to shop, and then return home in a short span of time. The cars ran frequently, leaving from Burlington to Graham every half hour from 6:30 a.m. to 11:29 p.m., and they left Burlington for Haw River every hour between 6:30 a.m. to 6:30 p.m. The same schedule was followed for cars leaving Graham for Burlington and Haw River. On Sundays, however, service did not begin in either community until 7:30 a.m., but the cars still ran until 11:29 p.m.

The Sunday schedule provided an opportunity for entertainment that had not been possible in the past. Many residents would spend Sunday afternoons riding the streetcars, much like tourists, from one area to the other. This was particularly true in summer, when the sides of the cars would be removed for a unique form of air-conditioning.

The crews worked an eleven-hour shift. The first crew began at 6 a.m. and worked to 6 p.m. with an hour for lunch. The second crew was split, working from

6 a.m. to noon, returning to work at 6 p.m. A third group came on at noon and worked until the end of the day's run. Such extended hours were offered to allow people to ride the streetcars to work, and many school students rode them back and forth to class every day at a special rate.

This list of hours came from Piedmont Railway & Electric Company's schedule of cars, which was revised on May 18, 1916. That schedule also included the following information: "The leaving time is published for information only and is not guaranteed but will be adhered to as near as possible.

"Persons wanting to board an approaching car are requested to give the Motorman a signal. Please have fare in hand on entering the car. This will help us to run on time."

While much emphasis was placed on being on time, it was not unusual for the streetcar to make a sudden stop every now and then. Some of the motormen had an arrangement with a local restaurant to provide rabbits and squirrels they saw on the route. If one was seen near the tracks, the car might stop long enough for one of the crew to rush off with rifle in hand to bag the prey.

Motormen had to be alert for animals on the tracks and for horses and buggies at crossings. Yet, there were few accidents. At other times, mechanical difficulties

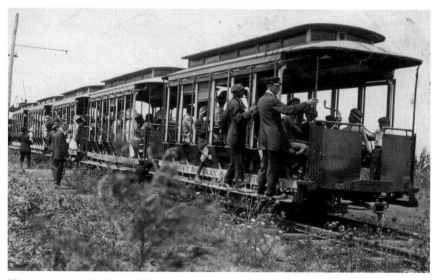

The streetcar was the first public transportation in Alamance County. It ran among Burlington, Graham and Haw River, and people could ride to work and school. In summer the sides were removed to allow for "air conditioning."

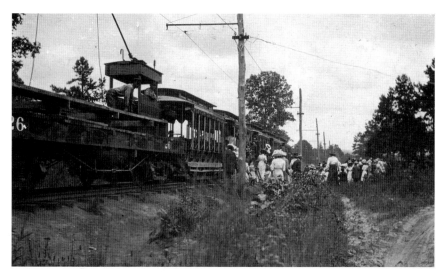

At times there were problems with the electric streetcars, causing delays. When that happened, passengers often left the cars and enjoyed the breeze on the ground beside the tracks while the workmen made repairs.

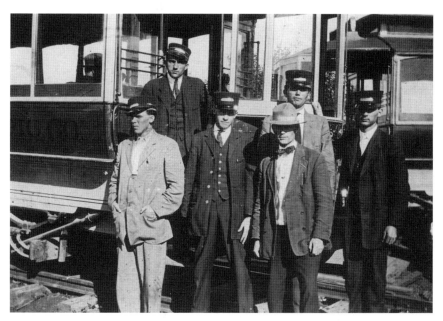

These are the conductors and motormen who operated the streetcars in Alamance County. The crews often had arrangements with a local restaurant, and they would shoot squirrels and rabbits along the tracks for the restaurant's menu.

would occur, and the passengers might leave the cars and rest on the grassy banks along the tracks until repairs could be made.

One of the major problems encountered by the streetcar was snow. In winter, the tracks often would be covered, and when that occurred the entire force of motormen and conductors would be called out to clear the tracks. It was during one of these snow situations that the line's first superintendent, George W. Hatch, was killed.

The accident happened near the junction of the Burlington, Graham and Haw River tracks where a wagon road crossed the streetcar rails. Ice had formed, and the streetcars could not get across the slick spot. Hatch took one of the cars and backed up to get a flying start, hoping to break the ice and cross over with momentum. He raced at full speed to the spot, and when the car hit the ice, it jumped from the tracks into a field. A big air pump tore loose from the car and fell on Hatch. He lived only a few hours.

The cars began their operations each day from a large garage or car barn on Rainey Street behind the Duke Power operations center on North Church Street. The building later was used by City Laundry and Cleaners for many years but was destroyed in a spectacular fire in 1941.

Streetcars ran on rails that were laid in the streets joining the three communities. Power was supplied from lines running above the streets. The rails remained in the streets for many years after the line stopped operating, but most were dug up during World War II as metal was sought for the war effort. In more recent years, city crews have dug up some of those overlooked rails as they made repairs or dug for utility lines.

Not too long after the streetcars began operations, there were plans by the electric company to extend service to other areas of the county. There was one story in the newspaper that outlined extensive plans to take the line north to Ossipee and Altamahaw, but for some reason that never occurred.

The City Burns

In the history of most every city, there is the "big fire," the business district fire remembered for decades as the one that almost destroyed the city.

Burlington is no different. We had our "big fires" just like other cities, and the one that we have remembered the longest occurred in 1918 on Main Street.

There are few photos from that fire, but one has remained to show us the hulks of burned out buildings, which only the day before had been the center of Burlington's retail activity.

The fire hit the block of South Main Street between Front and Davis Streets. That was for many years one of the two or three most active sections of the business district.

Fire broke out in daytime hours when people were shopping in the stores. It apparently had its origin in the M.B. Smith Furniture Store near the north end of the block and quickly blew out of control. Heavy smoke billowed out of the building, and one volunteer fireman from that day remembered that as he approached downtown, there was smoke over the entire business area.

Burlington's fire department in that period was manned only by volunteers, but they quickly responded and did their best to attack the flames. However, it was a very windy day, and the weather was more than the firemen could overcome.

McLellan's 5&10 was next to the furniture store, and it was a busy spot. Although it held a number of people that morning, it was quickly evacuated of employees and customers. The wind carried the fire from one building to the next, moving south along the street toward Neese Jewelry on the corner of Main and Davis.

It appeared for a while that the entire block would be destroyed, as the firemen were nearly helpless in stopping the blaze. The fire equipment the volunteers had was simply not adequate to fight such a blaze. Because of the desperate situation,

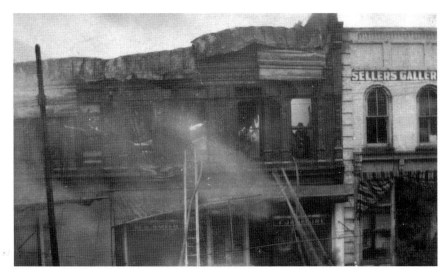

Fire struck the main business block of Burlington in the fall of 1918, destroying many of the town's retail operations.

the call went out to the fire department in Greensboro, twenty-five miles west of Burlington. Help was needed quickly.

Greensboro answered the call and placed a fire truck and other equipment on a railroad flatcar and sent it to Burlington. One story has it that the fire engine rolled off the train at Glen Raven, just west of the city limits, and it is not certain if the Greensboro equipment was really used. However, it is known that Greensboro firemen came into the city and directed the Burlington volunteers in battling the blaze.

When it appeared that the fire would take the entire block, C.F. Neese, who operated the jewelry store, began moving his jewelry cases out of the store and down the street to the Grotto Theater in the next block.

Next to the jewelry store was Kirk-Holt Hardware Company, long a well-known downtown business. As the fire burned into that store, firemen were able to get to the second floor and the roof and fight the blaze from above. That finally gave them some advantage over the flames, and the fire was finally extinguished, just before it could burn into the jewelry store.

While the wind was an enemy for a while, it finally shifted as the flames neared the end of the block. Had that not occurred, even the help of the Greensboro firemen may not have been enough to save the jewelry store.

Several businesses along the street, however, had been gutted. Roofs had caved in and all that was left were the exterior walls and a heap of burning rubble inside.

When this fire occurred, there was little to stop the spread of flames. There were no fire walls between buildings, and there was little the firemen could do but attack the blaze with water and hope for the best. They had no ladders to get them above the fire, and they could not get into the source of the flames.

The block was rebuilt in 1919, and although there have since been some major fires in that same block, none approached this one in terms of damage. A serious fire struck a clothing store in later years, but fire walls contained the blaze and enabled Burlington firemen to control it quickly.

It is this 1918 fire, which occurred shortly before the end of World War I, that is remembered by old-timers as the "big one," the fire that almost destroyed Burlington.

Old Hickory Division

In the early part of the twentieth century, there was not a lot in the way of adventure for young men growing up in Alamance County. There was the prospect of a few of them going to college perhaps, and some might have had the opportunity of entering the family business. Most others went into the textile mills and began the workaday life that their parents had lived before them. For the really adventurous, however, there was the National Guard. They could be soldiers, at least for a while each year.

By 1914 there was a war going on in Europe, and the United States was on the sidelines, vowing to remain neutral. However, those in the Guard knew they might be called to duty at some point.

They may have been surprised, however, when their duty call came. The United States was still not at war in Europe, but there was trouble along the Mexican border. A bandit named Pancho Villa was raiding United States towns and leaving death and destruction along the way. He had tried to gain the Mexican presidency and had hoped for U.S. support in gaining that post. The United States, however, backed his opponent, who won. That angered Villa and he began border raids to try to lure the United States into attacking Mexico.

From 1915 on, he caused great concern along the border. U.S. troops were sent there, and finally they were sent into Mexico in pursuit of Villa. National Guardsmen were called to secure the border, and that is where some members of the local unit found themselves. Those men were members of the 30th Infantry Division, known as the Old Hickory Division in honor of President Andrew Jackson. Members of the unit came from North and South Carolina and Virginia, with draftees from other states.

The United States did get into World War I in 1917, and the Guard unit came back from the Mexican border to prepare for Europe. It was not until May of 1918 that the

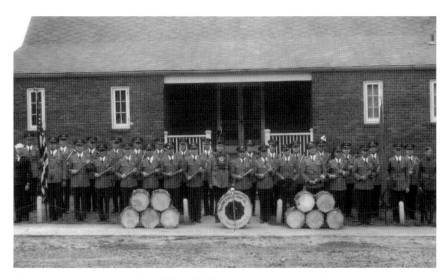

The drum and bugle corps of the Walter B. Ellis post of the American Legion poses in front of the Legion Hut in Burlington. Members fought in World War I with the 30th Infantry Division.

unit landed in Calais, France. That was a long way from home for the Alamance County lads. And if they had wanted adventure, they were about to get a good dose of it.

They made up the 3rd North Carolina Infantry, Company I, and they were sent to Camp Sevier near Greenville, South Carolina, for a short basic training period.

The 30th North Carolina joined the II British Corps when they landed in Europe and became the first U.S. unit to enter Belgium in support of the 33rd and 49th British divisions.

The unit's first offensive operation came on August 31 and September 1 in an area known as the canal sector. The division advanced 1,500 yards and took fifteen prisoners plus a few weapons. As a result of this raid, the unit could positively identify the location of the 236th German division, a unit that had been the object of a hunt for six weeks by Allied forces.

On September 29, the 30th Infantry Division, with many Alamance County men in its ranks, joined the 27th U.S. division and the 46th British division in an assault on the famed Hindenburg Line. The Germans had boasted that no one could cross that line.

There was indeed an impressive defensive line established. Tunnels linked systems of trenches and vast fields of barbed wire. There were machine gun emplacements located so the Germans could bring heavy fire on all approaches. Dugouts were all

about, lined with timbers. Some were thirty feet below ground, capable of holding up to six men. The tunnels had secret entrances, and the biggest could hold an entire division. Electric lights provided illumination.

Many felt an attack on those defenses would be a suicide mission, but on the morning of September 29, the 30th Infantry Division struck along a three thousand-yard front. The troops captured the entire Hindenburg system in their sector and the troops in the tunnels were captured.

The 30th pushed on to take a series of eight towns in the area and overcame two German divisions in the process. After that, the 30th was withdrawn for two days before being sent back to the front.

From October 8 through October 11, the division again struck, capturing 36 small towns, 45 officers and 1,889 enlisted troops. The 30th encountered units from 14 different German divisions on this campaign.

Again on October 17, 18 and 19, they took several more towns and captured more German troops. The 30th was given a rest near Amiens, but two weeks later the unit received an unexpected recall to the front. Before any action could take place, however, the Germans had surrendered and signed the armistice.

The Old Hickory Division then was released from the British Expeditionary Force and returned to the American Expeditionary Force and transferred to the Le Mans area in France. The unit had captured 72 field artillery pieces, 26 trench mortars, 426 machine guns and 1,792 rifles. They captured 98 officers and 3,750 enlisted men. The 30th lost 3 officers and 24 men as prisoners, with 44 officers and 4,823 men listed as casualties, but no figure was given for the dead. Many of the casualties were victims of gassing, which took a deadly toll in World War I.

The Alamance County War Memorial in Graham honors the dead from this county in all wars, and the list of World War I dead from Alamance includes ninety-seven names, most of whom were probably members of the 30th Infantry Division.

After the war, the young men came home and entered many different roles in the local community. There were doctors, attorneys and other professionals. One became an owner and editor of the local newspaper. Many of those veterans played a major role in shaping Alamance County in the years after the war.

The veterans also set up a post of the American Legion and named it the Walter B. Ellis Post, honoring one of the first young men from this county to die in World War I. The unit had a popular drum and bugle corps for many years, and the post has continued in operation ever since its organization.

Light Comes to Burlington

In 1921, Burlington was still pretty much in the dark. Literally.

When the sun went down, there was little light in the business area other than that which shone from some of the stores. There were, of course, a few gas and oil lamps on the streets, but they provided little illumination. Burlington needed streetlights—electric streetlights. In April of 1921, those needed lights became a reality.

The lights were eagerly awaited, something proven by the fact that what might have been the biggest crowd at any single event in the town's history to that point turned out to see them turned on for the first time. Up and down Main Street, and along Front and Davis Streets and on other side streets, there were posts holding clusters of three white globes, which enclosed incandescent light bulbs. They would be considered pretty dim when compared to the brilliant streetlights of today, but in 1921 they were dazzling. Some called the lights Burlington's "great white way."

The local newspaper reported that on that night Burlington was "flooded with light from beautiful clusters of street lights," and the streets were flooded with local residents out to see this special moment in the city's history. This night had been planned as a big block party for the whole town. There was a variety of contests for all age groups. The best dressed and the worst dressed were selected.

The newspaper reported, "There were solemn, stern businessmen rigged up in fool costumes acting like monkeys, dignified ladies made up to look like frights, and boys and girls that looked like they just landed in town from the South Sea Islands. There were handsome couples dressed in foreign and colonial costumes and looking like the real McCoy. The parade was up and down with fun and frolic everywhere."

There were little bazaar booths up and down the streets selling refreshments of various kinds, and almost everyone had horns and confetti. It was indeed a festive occasion. Prizes were given for almost anything one could imagine, and the list

of winners in the newspaper was lengthy and included names of many people well known in Burlington's history. There was even a queen of this streetlight event. Miss Helen Heritage was crowned queen for the night, and she was carried through the streets in a royal chair hoisted by four young men.

One of the celebrants on this particular night thought it would be good to figure out the wattage per square yard for the city's new lights. He determined that Burlington was the best lighted city in the entire United States at the time, "not excepting the richer and larger cities" of the nation.

Another account of the event noted that the people on the streets included "well-behaved people from all parts of the county and state. It was the best behaved crowd we have ever seen, and we did not see a single disturbance occur and not an arrest was made although a large force of extra officers was on duty. The people were out for a good time and had it."

There have been some other big celebrations in Burlington's history. There was a huge parade at the end of World War I, the big Alamance County Centennial Parade in 1949 and several Miss North Carolina Beauty Pageant Parades in the 1950s.

However, accounts of the streetlight celebration reveal that it ranked right at the top on the list of the most exciting and most enjoyed events in Burlington's history.

The City Gets a New Hotel

In 1923, Burlington was a little North Carolina town on the verge of bigger things. That was the year Burlington Mills was founded, and other industry was growing in the postwar years. Hosiery production was soaring, and Burlington was building a reputation as "the Hosiery Center of the South."

With that growth, many here saw that Burlington needed a new hotel. Community leaders wanted a modern hotel that could become a focal point for Burlington. Not only could it serve the traveler, it could provide banquet rooms for meetings and state groups could come for conventions.

There were some hotel facilities here, but they were dated and not competitive with those in other cities. The old Piedmont Hotel sat a few blocks up Main Street. It was built in 1906, had no meeting facilities and was not very much up-to-date. There was the Ward Hotel on Spring Street, but it was even older than the Piedmont and not a location that would ever attract many visitors. There had even been a hotel in Graham early in the century, the Vestal, which was located on Court Square, but it is not certain as to when that hotel closed.

The Burlington Chamber of Commerce took the hotel plan as a project, and a program was developed to raise funds for the construction of such a facility. A goal of $250,000 was set, and a group of citizens of Burlington began efforts to raise that amount in pledges from the community. The drive reached its climax in July of 1923 when the solicitors began to near the magic figure. On July 16, the volunteers reported they had raised $237,000, and a story perhaps further inspired the fundraising at a noon luncheon at First Christian Church:

Drive chairman W.E. Sharpe and drive commander H.F. Mitchell had gone to Greensboro that morning to contact a man who owned a large amount of property

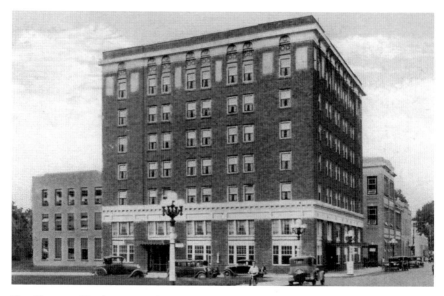

The Alamance Hotel was erected in 1925 and became the focal point for many activities in the community. The hotel was built as the result of a Chamber of Commerce effort to provide a much needed facility to the town.

in Burlington. They failed to get a pledge of any help from the man. Instead he told the two solicitors, "If Burlington wants a hotel, let her build it herself." The retelling was incentive enough for all of the workers to go even harder for the remaining amount.

There were some prizes handed out at the meeting on July 16. S.C. Stanley won a watch for the largest number of subscriptions at twelve, and B.V. May won another for the largest amount of money: $1,600. The high team for the day was headed by W.R. Freshwater, and the high division was led by A.H. King.

The meeting was saddened by the report of the death of Colonel Robert L. Holt, president of the Burlington Hotel Corporation and chairman of the hotel drive executive committee.

The workers were challenged to go out that day and end the drive before nightfall. The next day it was reported that 730 people had subscribed $250,900 for the construction of a new hotel in Burlington. The final report meeting turned into a celebration. H. Frank Mitchell's team was the high unit and won an American flag, and M.B. Smith's team won a live goat! It was the go-getter award, and Smith put the animal on display at his furniture store on Main Street.

Up Main Street from the Alamance was the older Piedmont Hotel. The building was erected in 1906 as the home of Piedmont Trust Company. The upper floors contained the hotel rooms.

It was reported at the final meeting that plans for the new hotel had been completed by Charles Hartman of Greensboro and the site had been agreed upon; the next step was to begin to collect the subscriptions. A newspaper report on July 17 had this to say:

"The construction of the building will not start until some of the money is paid in. Then it is planned to start work as soon as seems wise and expedient.

"There is lots of work to be done. The big job is yet ahead. An operator must be contracted for we will pay a good rate of interest on the investment and at the same time give good service."

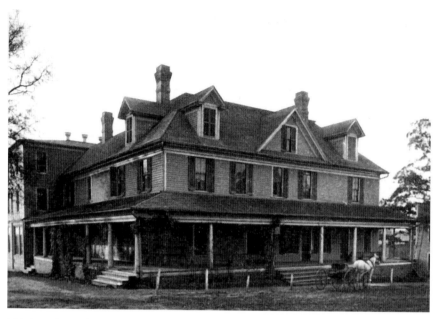

This hotel began life as the Burlington Inn, but in later years the front portion was torn away and the brick building to the back became Ward Hotel. This hotel was used for many years, mostly by permanent residents.

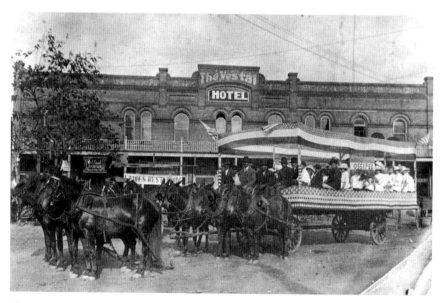

The old Vestal Hotel in Graham is seen in a photo from the early years of the twentieth century. It was located on Court Square directly across from the Alamance County Courthouse.

The action that had taken place back in 1923 eventually led to the construction of the Alamance Hotel at Main and Maple in Burlington. It opened in 1925.

As the years passed, the hotel indeed became what the people in 1923 had visualized: a focal point for Burlington. The hotel was the site of dances, special parties and high school dinners. Its lobby was a busy place through the years as visitors came and went. It was the scene of banquets for special occasions. The city's civic clubs had their weekly meetings there. Nationally famous speakers used the ballroom for addresses, and nationally famous people slept in the rooms of the hotel.

One not-yet-but-soon-to-be-famous visitor did *not* stay there, however. In 1956 a young entertainer came to Burlington for a concert at Williams High School auditorium. He checked the Alamance for a room, but according to desk clerk George Best, he found it too expensive. The man went up the street and stayed at the Piedmont. That young entertainer was Elvis Presley.

For three years in the 1950s, the hotel was the headquarters for the Miss North Carolina Beauty Pageant. Contestants stayed there, and many events related to the pageant were staged at the Alamance.

As the years passed, however, things changed drastically. Highway 70, which once ran through downtown Burlington, was moved to a bypass south of the city. Motor hotels appeared there, and clubs even moved their meetings to the more modern facilities in those motels. The parties and dances went the same route. Finally, most of the Alamance business was from permanent residents, and eventually the hotel was closed. New life would come, however, when the facility was reopened as a retirement home in later years.

Grocery Shopping

Today's shopper can pop into the supermarket—there seems to be one on every corner—at most any time of the day or night and pick up whatever the family might need at the moment. Name it and you can probably buy it at one of the markets, regardless of the season, regardless of the item. Every time a new market opens, grocery shopping becomes easier and more convenient, with a bigger variety of items than before.

Burlington and Alamance County have their share of good markets, and many older residents are far more grateful than today's younger shoppers. The older ones remember the time when you shopped in the little neighborhood grocery store without always finding what you wanted. The desired fruit or vegetable might not be in season. The store might not have stocked some of the fancier or costlier foods of the day. Those stores geared themselves to the everyday needs of working families, most of them textile families with limited funds.

J.M. Tisdale operated a typical store of the day in Burlington in the early 1900s. J.M. Tisdale Groceries was located in downtown Burlington, and it operated into the second decade of this century. A brochure published early in the century to promote Burlington had this to say about this grocery store:

"No town is complete without a first class grocery store. We are very fortunate in having in our city a man who makes the business a study, and who always anticipates the wants of the house keeper in having upon his shelves and in his store the very latest table delicacies."

One might believe Mr. Tisdale had a publicity agent as one reads on through the lavish praise:

There is no store of the kind in the state that is kept in a more attractive manner; there is no place in the city where a nicer line of fancy articles that appeal to the palate are kept. By making a specialty of keeping farm products fresh from the fields, he furnishes the tables of a hundred families every day with the delicacies that go so far in making the lives of people living here pleasant. The store of Mr. J.M. Tisdale is indeed Burlington's supply department for the table and fortunate is any town which has such a store.

Grocery stores of that day were pretty much alike. The wooden floors often were covered with something that felt a bit like sand mixed with what seemed like oil. It was a material to help keep the place clean. Scales hung from the ceiling, shoppers placed vegetables and such in the tray and the dial spun to give the correct weight. Most stores always had a stalk of bright bananas hanging from the ceiling, and the shopper merely pulled off the number desired. Produce was often displayed in baskets around the store, and there was usually a special rack for bread and other bakery products. The meat department was usually in the

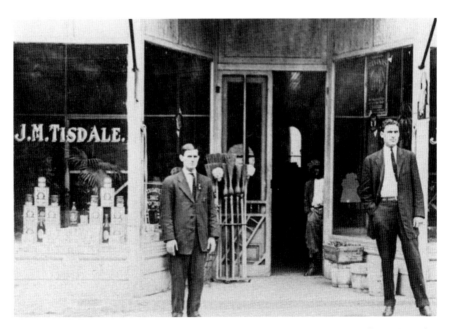

Tisdale Grocery was located in downtown Burlington in the early 1900s. This front view of the store was made about 1909.

back of the store, where the butcher would cut the shopper's selection to the weight desired.

In later years, every store had a drink box where colas were sold individually. That box might have had a sliding top, and you opened it to peer inside and find your choice. The bottles sat in refrigerated water.

Somewhere in the store was the cash register, often one operated by a hand crank. The grocer would total up the bill and collect as the groceries were bagged. Some stores, especially in a mill town like Burlington, gave credit. They allowed the customer to buy groceries at various times during the week, keeping a record of each transaction. Then at the end of the week on payday, the customer would come in and settle up the bill.

The Tisdale store had neither the benefit of refrigeration nor a lot of the other advantages of later stores and supermarkets. Like other stores of the day, they tried to provide an abundance of the goods they knew their customers wanted on

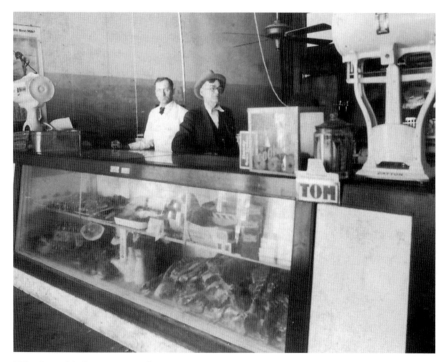

Miles Meat Market was one of Burlington's early specialty shops. The meat market and the family grocery stores in the community served the area well for many years before the arrival of supermarkets.

a regular basis. They probably offered home delivery of groceries, as it was difficult for many customers to get to the store because of a lack of travel conveniences or because they worked when the store was open.

There were community grocery stores around the town in the 1930s, 1940s and into the '50s and '60s. There were still a number of mill communities, and each had a neighborhood grocery. One well remembered was Atkins & Burnette on the Burlington Mill "hill." Henry Burnette, a pleasant white-haired gentleman, and his wife ran the store and lived in an apartment on the side. They served the mill community for many years, and Mr. Burnette was so well liked that he was elected to Burlington's City Council.

His was a typical community grocery, and he had those little books on a shelf with the names of his customers on them. They were the account books. He kept them for the families who would settle up each payday.

There was a more specialized market in the downtown area for many years. Miles Meat Market was a butcher shop of the era. Little was sold in the store except meats, but a wide variety was offered.

The Old Movies

Today's movie theaters often are mega film palaces with multiple screens, often more screens than an entire city had some years ago. One can choose from a dozen or more titles in a single theater. That's certainly the case in Burlington and its neighboring communities in Alamance County.

There was a time when Burlington had four separate theaters downtown, and Mebane, Haw River and Gibsonville each had a single location. In Graham, there were two. That was a total of nine screens for the entire area.

It all had to start with one, however, and it is believed that the first theater in the area was the Grotto, which used to play silent films in Burlington.

One of the movie pioneers in Burlington and in the state was J.R. Qualls. Qualls had a theater in Burlington named the Paramount. When he opened it, the movies were still silent. The only sound was provided by a piano or organ that played along with the film while captions displayed on the screen. The most popular theater musician in Burlington was Henry Easley, a blind man who was also the premier piano tuner of the area.

It was in 1928 that Qualls made a decision that would change the movie history of Burlington. He needed a new organ for the theater, a considerable expense. He had to choose between that and spending that same money on equipment that would allow him to show movies that had sound. Talking pictures were just beginning to make the scene across the nation, and Qualls watched with interest.

He finally decided to opt for the sound equipment, although many of his peers in the industry were afraid to make the gamble.

Qualls installed the equipment, and Henry Easley lost a job. In 1928 Qualls brought the first sound movie to Burlington. It bore the title *On Trial*.

People came from all around the area to see this new phenomenon. The first effort was not a complete success to say the least. There was a record of the script, which ran along with the film, or at least it was supposed to. Often the sound and film were not properly synchronized, and that led to a lot of confusion—and laughter. Warner Brothers had produced the record system, but a year later 20th Century Fox produced the first movie with the soundtrack on the film itself. "Talkie films," which began to feature stars like Al Jolson, became extraordinarily popular.

There were two other theaters in Burlington at the time: the Lyric and the Carolina. The Lyric burned about the time the talkies came, and Qualls bought the Carolina and also introduced talking movies there. He was also the first to show talking movies in Davidson and Cabarrus Counties in North Carolina. Eventually, Qualls sold both the Carolina and his Paramount Theater to the Paramount Picture Company.

Later, in 1938, Qualls built the State Theater and continued to show first-run movies in Burlington for many years. There were four theaters in Burlington in that period. The Paramount and State ran movies when they were first released.

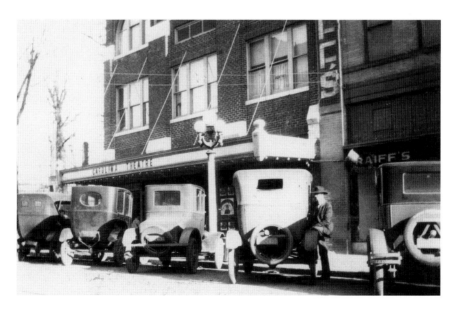

The Carolina Theater was one of four movie houses in Burlington for many years. The Carolina showed western movies most of the time, and often there would be stage appearances by some of the cowboy stars of the era.

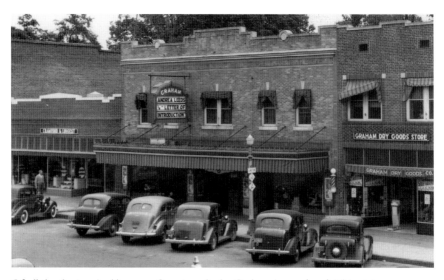

Of all the theaters in Alamance County, only the Graham has endured. This picture was taken about 1940, and the theater is still in operation today.

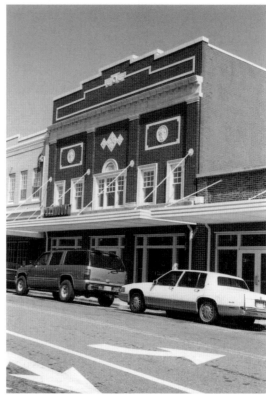

The Paramount was the site of the first talking picture in Alamance County, and it had a run of many years as the premier theater in the county. It stood closed for many years and was near demolition but was later restored.

The Alamance was a second-run theater, and it later became known as the Towne. The Carolina was the cowboy theater, specializing in westerns, and it was packed with kids every Saturday.

Burlington at one time had a theater named the Victory, which was open only to black residents. The Victory appeared in the days when the South was still segregated, and it was located in the area of Burlington that had a number of black businesses. In addition, the Carolina Theater had a balcony for blacks.

Graham had two theaters for many years, the Graham and the Alco. They were just a couple of doors apart on Graham's Main Street. There was a theater on the main street of Mebane and one in the center of Haw River. Gibsonville, a town split between Guilford and Alamance Counties, had a theater located in the main business district on the Guilford side.

After the advent of television, those theaters began to close over the years, one by one, opening the way for the rise of the multi-screen complexes in use today. The single-screen theater in Graham is the exception. It has remained open and continues operations, offering relatively new movies at a greatly reduced price.

The other theaters were long since closed, and most of the buildings have been demolished. Burlington's Paramount has found new life however. In the 1990s, the theater building was totally renovated to serve as the site of theatrical performances, concerts, business seminars and such. It is owned by the City of Burlington and is operated as a part of the Department of Parks and Recreation.

The Phoenix Rises

In the history of any institution, there are certain events that help define its character and shape the course of its future for all time to come.

There have been a number of such instances in the history of Elon University, an Alamance County institution of higher learning that has grown in popularity in a spectacular way in recent years. It has gained recognition nationwide for its unique academic programs, which include study abroad and public service projects. It has been high on the list, and is moving higher each year, in the annual survey of colleges and universities done by U.S. News and World Report.

But Elon had to cross many bumps to reach its level of success, and no bump was bigger than that placed in its path in the early morning of January 23, 1923. At 6:30 a.m. on that cold winter morning, a student named William B. Terrell looked out the window of his room across the dark campus.

He saw a light in Main Building across the way, and as he watched, he realized that light was not steady. It flickered. That was a fire! He ran across campus and was going to go up to the second floor of Main where he had seen the light. But as he opened the door, smoke was so heavy he could not enter. He spread the alarm and ran to call for help from Burlington and Gibsonville fire units. The college sat between the two communities.

Students poured from their rooms, and some attached fire hoses to the hydrants nearby, but it was a useless effort. The fire had too much headway. When the two fire departments arrived, they found their hoses would not fit the college hydrants. Soon, the college's water supply was all but exhausted, and the flames roared on.

A strong wind blew the flames across to Alumni Building and fire caught under the eaves, but students and the firemen were able to put that blaze out.

Old Main Building was the center of activity on the campus of Elon College until it was destroyed by fire in 1923. Before the fire was out, plans were being made to rebuild.

Main Building was destroyed. As it burned upward, large iron safes in the president's office and in the rooms of the literary societies crashed to the bottom of the building. The college bell also crashed from its tower.

Elon College had been founded in 1889 and graduated its first students in 1891. There had been difficult times, of course, as the school tried to find its way, but nothing compared to this fire.

Before the fire was out, the administration was making plans. President Harper called a meeting of his faculty for 10 a.m. that morning. There was discussion of the situation, and finally it was decided to call a meeting of students and the general public to air the problems further. A large crowd gathered in Alumni Building, and during the discussions, there was never any suggestion that the school would not go on. When that meeting was over, the feeling was that somehow, Elon would rise from the ashes as a bigger and better institution.

Heavy support came from Alamance County. An editorial appeared in the Burlington *Daily News*, reading:

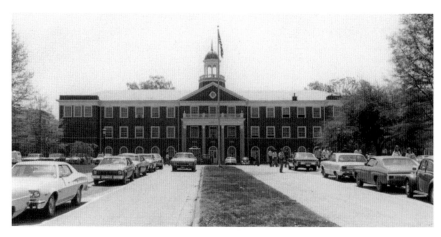

Alamance Building rose from the ashes of Old Main after the fire in 1923. It was named in honor of the county because of the tremendous support given by the community in helping the college rebuild after the fire.

"For about 30 years, Elon College has been sending forth young men and women into the world equipped for service. Today she stands wounded and bleeding and mutely appeals for help. Her cry will be answered. We believe that the news will go forth to the world that she will arise forth, out of her ashes, equipped for greater opportunities for work and with a plant that will stand as a monument to what love and confidence can do when the cry for help comes."

Trustees convened the next morning despite a winter storm that coated the area with ice. It was said the meeting had the largest trustee attendance ever. The board was not downcast about the problem. In fact, members came up with a long-range plan that included four new buildings. That would require $300,000, and the trustees quickly went to work to raise the money. A meeting was held at a theater in Burlington on January 28, and the fund-raising drive was kicked off.

Elon did rebuild. A new building rose where Main had stood and it remains the focal point of the campus. It is named Alamance Building, a way of saying thanks for the generous support Alamance residents gave, along with many from other areas, to help Elon rebuild after that disastrous fire.

A few years ago, a new mascot was chosen for the school's athletic teams: the phoenix, that fabled bird that rose from its own ashes to fly again. Elon College indeed rose, growing to become Elon University, and its wings continue to reach new heights with every passing year.

Believe It Or Not

Paul Simpson was a mailman. Every day he walked mile after mile, faithful to his duty of delivering the mail to his patrons. And every day when he finished his twelve to fourteen miles of walking, Paul went home, changed his clothes—and his shoes—and ran. And he ran and ran and ran.

Paul Simpson was not only a mailman. He was a runner of almost unbelievable accomplishment. He was so unbelievable in fact that he wound up featured in *Ripley's Believe It Or Not*.

Paul, who was better known by his nickname, Hardrock, gained that renown by racing a horse from his hometown of Burlington to the coastal city of Morehead City, 250 miles away. Hardrock not only won that race, he ran the horse to death. The horse dropped dead near Goldsboro, North Carolina, trailing Hardrock at the time by some twenty-five miles.

Hardrock was an athlete through and through. He had been running since he was big enough to walk. If he had to do an errand, he ran. When he joined the army in 1919, he ran every morning before doing his military duties. He fibbed about his age, getting in the service at age fifteen.

He actually was in the army before he finished high school, but it was at Burlington High that he earned his nickname for his football achievements. He played every minute of every game for two seasons. He was tough. He was running then as well, competing in track. It was when he went on to Elon College that he really starred in track. He competed in almost very competition, and he set a state record in the six-mile run. He was also a very good boxer.

A year after Hardrock ran that horse to death, he entered the ultimate marathon—a race across the United States. He participated in The Transcontinental Footrace, an event carrying a purse with the unheard of sum of $25,000 to the winner.

Paul "Hardrock" Simpson was known as Burlington's running postman. He was a marathon runner who twice participated in transcontinental runs and once made it into *Ripley's Believe it or Not* for racing a horse—and winning!

Hardrock was one of almost two hundred who started that race on March 4, 1928. They ran from Los Angeles to Madison Square Garden in New York City, covering the almost 3,500 miles in almost three months. Hardrock finished in thirty-sixth place, one of only fifty-five runners to make the entire race.

Later there was a second transcontinental race, this time from New York to Los Angeles, and he was one of sixty-two runners. He finished in fifth place, one of nineteen to finish a race that was run in more rain than sunshine. Although the prizes were high and Hardrock finished well, he said he never realized very much money from those events.

Hardrock ran in endurance races in many parts of the United States and Canada. He ran several times in Canada, setting three unofficial world records.

While doing all this running, Hardrock managed to work in enough time to attend Elon College near his home. He graduated in 1931 and then stayed around

to coach the track team for two years. He also coached at Burlington High School in 1933, where his team won the state championship.

Hardrock never gained many riches for his running, but he certainly gained fame. He died in 1978, but he is still remembered for his amazing running achievements. Even when he began to get to the age when most people would have stopped running, Hardrock found new reasons to keep going. He would run every day to keep in shape, and he would find special events in which to participate, not in racing against others, but racing against time.

He became a fixture at minor league baseball games across the nation, where he would begin running with the first pitch of the game and run until the final out. The teams would pay him to run to help increase their crowds. He would run the outfield, left field to right, right to left, back and forth until the game ended. Some teams ran contests, allowing the fans to guess how many miles Hardrock would run during the game. Extra innings did not bother him. He just kept running.

For many years Hardrock did a birthday run. On his birthday, he would run a mile for every year of his age, and that meant, of course, that as he got older, he had to run longer. In 1954, Hardrock was fifty years old. That year, instead of running to some other city in the area, he decided to make his run around Alamance County. He passed through several communities more than once on that hot September 2, making good time. He made his fifty miles in nine hours and forty minutes, some seven minutes faster than he did his forty-nine miles the year before. Only at the end of the day did he let anyone know that he "didn't really feel good all day." He had an upset stomach, but he ran on. When he finished his day, he said he went home and rested while Mrs. Simpson made supper. He recuperated and later that same week he was on the road to Durham, thirty-five miles away, doing a promotional run for the Durham newspaper. That birthday run was a regular part of the list of annual events in the community, and people looked forward to it, always wondering when it would end. He was into his sixties when he gave up the annual run.

Hardrock became a legend in North Carolina. He was known all across the state for his running abilities. Newspapers and television stations provided coverage every year for his birthday runs, and his baseball marathons received much publicity as well. He was featured in *Sports Illustrated* in 1960.

He was always modest, unassuming and even shy. You might say he just took all the attention in stride.

Early Motels

When a motorist looks for a place to make an overnight stop along one of the nation's superhighways, there is a wide choice of hotels and motels from which to select. They are often big, well-designed and landscaped and offer all the conveniences of home, and then some.

Those hotels are just as different from the roadside inns of the past as are the superhighways from the old two-laned roads that previously crossed the nation.

The roadside inns, or tourist facilities as they were often called, were quite simple. For the traveler, weary from hours behind the wheel on those narrow roads, they were all that was needed. There was a bed, a bath and a place to eat.

Unlike today's super hotels, many of these early facilities featured individual cabins rather than many rooms under a single roof. There was usually a large building out front that housed the office and a small restaurant. The cabins were single units, although some sites had duplex cabins. The motorist could pull the car right up to the front door.

There were two popular motor inns in the Burlington area for a number of years. They were pretty much alike: one on the east side, one on the west side. Both were situated directly on Highway 70, which then was the main east-west highway across North Carolina. That highway ran from Morehead City, North Carolina, all the way across the nation to California, close to the route followed by Interstate 40 today.

On the west side was Correct Time Inn. The name came from a clock that was located out front, but there was always a question of whether the time was really correct. On the east side was Travelers Rest. Both were outside the city limits but were only a couple of miles from the middle of Burlington.

Traveler's Rest was one of two pre-1940 motor inns that served those who traveled through Alamance County in that era. Traveler's Rest and Correct Time Inn were on opposite sides of Burlington, located on Highway 70.

Each was in business during the same period, with Correct Time Inn opening first. It started serving travelers in 1932. Travelers Rest was opened in 1937, and it operated until 1955. There is significance in that closing date, as it was the same year in which Highway 70 was relocated to a new highway south of Burlington and Graham. That highway would later become a part of Interstate 85-40.

The relocation of the highway designation meant that travelers going through the area would go along the new route, not past the front doors of the two tourist stops. Travelers Rest later opened as a restaurant under the name of Pine Valley Inn. Correct Time Inn remained open a number of years beyond 1955, but it too became more of a restaurant than an overnight location.

Travelers Rest was operated by H. Curry Isley and his wife, Maie Bass Isley. There were seven cabins behind the office and restaurant, and traffic moving across the state ran right by the front door. Mrs. Isley was the daughter of H.F. Bass, and his family operated Correct Time Inn as well. In 1949, Correct Time Inn advertised it had fifteen modern cabins and apartments, each with hot and cold running water and heat. Its café was described as one of the finest dining places in the county. Each site had a gas pump out front.

Travelers Rest advertised its restaurant locally, featuring chicken dinners, country ham and western T-bone steaks. There were four private dining rooms available and curb service was also featured. A card advertising the business had this notation: "You are a stranger here but once."

Both locations suffered during World War II, as private travel was heavily restricted by gasoline rationing. The restaurant at Travelers Rest, however, had good business. The inn was located quite close to the Fairchild Aircraft plant that operated during the war, and employees frequented the restaurant at mealtime, and company employees who had to travel here on business kept the cabins filled much of the time.

While most memories of the two sites have pretty much faded, the Correct Time Inn name has been revived in recent years. Located on the site of that old inn is a new shopping center that bears the name Correct Time Plaza, and there is a new clock out front.

A Medical Legend

For much of its history, Alamance County was predominantly rural, and visits by most people to the towns of the county were not very frequent. There was little way to go, other than by horse and wagon, so the people lived off the land as best they could and filled the rest of their needs at country stores.

But there was the problem of medical care. It was difficult for many to go to a town to see a doctor, so they relied on the country doctor for their medical needs. Country doctors were a special breed. They put their patients above all else and made great sacrifices to see to their needs. Most medical men could have gone to the towns and cities and had a much easier life, but there were some who committed themselves to country practice.

One such man in Alamance County was Dr. Floyd Scott. In more than half a century of practice in northern Alamance County, he became a legend to those who knew and loved him. He gained wide respect for the love and care he gave the people of his area. He lived in the Union Ridge community of Alamance County and tended the needs of people over a wide area of Alamance and surrounding counties. In the process, he brought more than six thousand babies into the world.

Floyd Scott was born in Alamance County, one of fourteen children, the son of a man who had begun a family tradition of political service when he was elected a state legislator in 1888. Floyd had a brother, Kerr, who later became governor of North Carolina and later United States senator. Another brother, Ralph, served in the North Carolina Senate and was one of the most powerful legislators in the state for many years. Floyd's nephew, Robert, the son of Kerr, would also serve as lieutenant governor, then governor of North Carolina.

But Floyd never gave thought to a political career. He wanted to be a doctor, and when he finished his medical training, he went to Union Ridge to begin his practice. In 1919, the young doctor rode a train home on borrowed money. His father met him in

Dr. Floyd Scott was a typical country doctor in many ways, serving his patients for over half a century and delivering some six thousand babies. He was the first doctor in the area to introduce telephones and radios to his practice.

Burlington, where he bought a couple of new shirts. He had no money left, so he had to catch a ride to the Ridge.

The young doctor thought he might have to work in agriculture for a while to make a living until he could get his practice started. But that was not going to be necessary.

The day he arrived he quickly found need for his services. He had to treat a baby and examine a family of eleven. He made a total of six dollars that day and never had to resort to farming to make a living. However, his presence was felt in agriculture. He bought farmland and found much of the land gone through erosion. Some locals who specialized in soil stabilization set up a crop demonstration project there to show people of the area the proper methods of saving their most valuable commodity, the land.

The first year he was on the Ridge, he encountered a smallpox outbreak, and the great flu epidemic was still underway. He said he once went for twelve days during that flu crisis without ever sleeping in a bed and was hardly able to take his shoes off. He later encountered spates of typhoid fever and ringworm. To fight ringworm, he went to a teacher at Anderson School, and the problem was eliminated through a program of education.

Dr. Scott at first rode horseback in his travels, but he often walked as many as ten miles per day. He later bought a Model T Ford, but still often had to wade creeks to reach his patients. When he bought the Ford, he had no idea how to drive, and he backed it into a tree the first time he was in it.

Communication was a problem for him in the early years, so he proposed an idea to his people—a telephone system. He provided the wire, and the people of the community provided the poles and labor to erect the system. The result was a system with five lines running from his office at his Union Ridge Home to the homes of patients in various areas of the nearby county. Other patients without a line in their own residence could go to those selected homes to call the doctor.

As years passed, his practice grew, and he again found communications problems. This time he came up with the idea of a two-way radio system between his office and his car so he would not have to return to his office after every call in the country. He could simply radio in, get instructions for other visits and make them before returning to the office. This was the first such medical use of the radio in the United States, inaugurated in 1954.

Dr. Scott practiced through the Depression, of course, a time when many of his patients had no money. However, those bills were paid in one fashion or another. There was one example of a person who paid for his own delivery into the world thirty years after the fact.

By 1949, Dr. Scott decided he and his patients needed a clinic to better serve their needs. His idea became a community project. When people learned of his plan, more than two hundred turned out to help with the construction. The result was a clinic built quickly and with very little special construction help.

Dr. Scott's practice always came first. He was in his office every day, seven days a week. He once said that he took two vacations early on in his career. He said that each time, a patient of his died. Had he been home, he said, he might have been able to save them. He never again took a vacation.

On the occasion of the two hundredth anniversary of his church, he was to be recognized for his service there. The minister called on him to stand, but he was not present. After the service, lunch was served, and the doctor appeared. It seems there was a baby who would not wait for the church service to make his way into the world.

Dr. Scott was Doctor of the Year in 1954 for the Alamance-Caswell Medical Society, and in 1969 he was honored for fifty years in the medical profession. The people of Union Ridge paid special tribute to him at a service in recognition of that achievement.

Dr. Scott practiced on until his death. By that time, he had one son in the clinic in medicine and another was practicing dentistry. He is still remembered by many in the community, and those who knew him recall his wry sense of humor, a sense of service and a feeling of humility.

He once said, "A rural doctor must have humility, kindness and discipline, both in himself and his patients. We've tried to bring this into the service of the community."

The Dairy Industry in County History

For many years, one of the most familiar sights in rural Alamance County was the silo standing in a field surrounded by a herd of cattle. The dairy industry was a major element in the economic makeup of the area, and it became the top moneymaker in the county's extensive farming operations, surpassing even tobacco.

Many families, especially in the southern and eastern areas of the county, made their living from dairy products derived from large herds of good cattle. Alamance County milk was sold to dairies in the Piedmont area of North Carolina, where it was processed and sent to the tables of families throughout the state.

The dairy industry was developed during the War Between the States. Prior to the war, Alamance was recognized as a leader in agriculture with extensive livestock populations. But during the war, those herds were destroyed. Horses were seized by the two warring armies, and sheep, cattle and hogs were slaughtered as food for the soldiers.

After the war, the South was in desperate straits, but a comeback led to making dairy farming one of the major operations in the area.

The Baltimore Association of Friends wanted to help their Quaker friends in the South, so they set up Springfield School and a model farm near Guilford College. From this model came the establishment of Sylvan Academy on Cane Creek in southern Alamance County. In 1867, an agriculture club was formed at the academy. The Springfield farm had a Jersey bull shipped to the Sylvan club with the understanding the club would pay the freight bill. However, when the club learned the bill was fifty dollars, they rejected the bull.

Caleb Dixon, a Snow Camp farmer, came up with the fifty dollars and took the little bull to his farm. This bull, named General Sherman, became the sire for a large and productive herd of Jersey cattle. He was sold at the State Fair in 1876. Farmers in southern Alamance could see that the Jersey, as exemplified by General Sherman, was a good breed of cow and much more productive than the scrubs they kept on their farms. They began to improve

their own herds. While Haw River's David Carr produced a herd of pure Devon cattle, a group of farmers pooled their resources and bought a prize Jersey bull from a breeder in Burlington, Vermont. The city was perhaps named for this particular bull in 1887.

Another farmer, William Burns, bought a Jersey bull and six heifers to improve his stock. Henry Ray later bought this operation and produced a large herd of dairy cattle. Parts of his herd were sold to H.A. Scott and Ralph Scott, who later established Melville Dairy in Burlington. Melville bought raw milk from the farmers in Alamance County, processed and bottled it, and then delivered it door to door to many customers throughout the area.

Prior to 1866 there were no fence laws in Alamance County, and the livestock ran at will over the countryside. Only the cultivated fields were fenced off to keep the cattle from grazing there. With no fences, a farmer may not have known actually how many cattle he owned. He never carried on a breeding program, and he may not have known if a calf belonged to him or not.

But as the herds improved, breeding became important. A good line of cows was essential if good production was to be obtained, and good production was vital if the farmer expected to make any money. Large pastures were fenced, more attention was given to proper feeding and the herds grew.

The number of dairy farms in the area declined in the late twentieth century, as farmland was turned to other uses. Some few families remain in the business, and most of them have large herds and operate on a very large scale. There are few small dairy farms left.

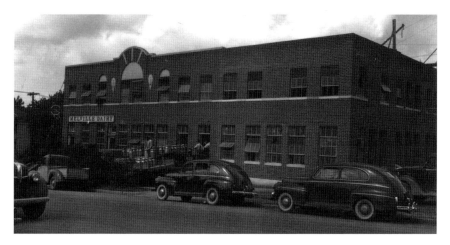

Melville Dairy operated in Alamance County through the latter half of the twentieth century. The plant was in Burlington. Its milk came from dairy farmers all across Alamance County, then was processed and delivered to Alamance County homes.

Three Governors

Mention the name Holt in Alamance County and many people immediately think of textiles. Edwin M. Holt started a cotton mill back in 1837, and later that mill began producing a dyed material that became known as Alamance Plaids. From that grew a textile empire that had a major economic impact not only on Alamance County but also on the entire state of North Carolina.

Mention the name Scott, and many people immediately think of politics. The list of offices the Scotts held ranged from county commissioner to commissioner of agriculture, to state representative, state senator, governor, United States senator, lieutenant governor and governor again.

The Holts and Scotts are not usually paired in history, but there is one instance in which they overlap. There was a member of the Holt family who indeed was a politician and held the office of governor of North Carolina. In fact, Thomas M. Holt was the first of three Alamance County residents to serve as governor of this state. W. Kerr Scott would also serve and he would be followed by his son Robert two decades after he left office.

Another thing that brings these three governors together is the fact that all three went to the governor's office from Haw River, one of the smallest communities in Alamance County.

Thomas M. Holt

Thomas Holt was the son of E.M. Holt and had been associated with him in the mills.

Born in Alamance County as the second son of E.M. Holt, Thomas studied at Caldwell Institute in Hillsborough and went for one session to the University of North Carolina. It was then that he decided he wanted a career in the family mill, so

Thomas M. Holt, a textile pioneer in Alamance County, became governor of North Carolina in 1893, moving from his post as lieutenant governor when the incumbent governor died in office. He was the first governor from Alamance County.

he persuaded his father to send him to Philadelphia to learn the dry goods business, where he became acquainted with dyed cotton goods. Later the knowledge he gained in Philadelphia would be valuable when he went back to the mill with his father: the two men pioneered production of dyed fabrics in the South.

In 1858, Benjamin Trollinger, a Haw River mill owner, was forced to sell his operation. E.M. Holt bought it, and Thomas was sent to operate it. He moved across the county to Haw River and lived there until his death. He took his brother-in-law, Dolph Moore, as a partner. In 1876 Moore was murdered in Haw River by an unknown assassin, and from that point on, Thomas Holt was in charge of mill operations.

Holt made his first move into politics as a county commissioner. In that position, he became a great advocate of public school education at taxpayer expense, but at the time it was not a popular position within his chosen Democratic Party. Democrats opposed education for poor whites and all blacks, but Holt stood fast and would not change his position to please his party.

He was president of the North Carolina Grange, an agricultural organization of farm families, for thirteen years. And for sixteen years he was president of the North Carolina Railroad and led that organization to considerable growth.

Thomas moved into politics and was elected to the legislature three successive times beginning in 1883, becoming Speaker of the House in 1885. While Speaker he tried to get a bill through the House to reduce working hours of employees without

71

cutting their pay. The bill failed, but Holt took that action in his own mill, cutting working hours from seventy-two per week to sixty-six. In 1888 he was nominated to run as lieutenant governor with gubernatorial candidate Daniel G. Fowle.

They were elected easily and moved into office. However, in 1891 Governor Fowle died, and Holt became governor, the first Alamance County resident to hold that office. He served out the two years remaining in the term and could have stood for reelection in 1892, but he declined the opportunity. His health was in decline, and he really wanted to go back to Haw River and textiles. Holt's son Charlie had operated the mill while his father was in Raleigh, but in 1893, Thomas Holt's political career was over, and he returned to his family business. He died there three years later of pneumonia.

W. KERR SCOTT

Half a century later, another Haw River resident would make his way to the governor's mansion. W. Kerr Scott had operated a dairy farm much of his life and had served in a county agricultural position before becoming secretary of agriculture

W. Kerr Scott, an Alamance County farmer who had been state commissioner of agriculture, became governor in 1948. He later was elected to the United States Senate.

72

for the state of North Carolina. In that post for eleven years, he traveled the length and breadth of the state, helping farm families improve their crops, their income and their way of life. He knew North Carolina farmers as perhaps no other knew them.

In 1948, he announced that he had been in that office long enough and was going home to Haw River. However, he entertained the idea of being governor of the state.

At that time, North Carolina's governorship was decided in a unique way. The Democrats were in firm control at the time. It was hard to find a Republican, and the governor's race was actually decided in the Democratic primary election, if indeed there was need for one. There was always a candidate whose time it was to run, as an unofficial rotation system was in effect. One election the governor would come from the western part of the state, the next election he would come from the eastern half.

Not only was Kerr Scott from the middle of the state, it was just not his turn to run, and party officials told him so. Charles M. Johnson was the popular choice in 1948, but he was contested by R. Mayne Albright and there would be a primary.

Shortly thereafter, there was a testimonial dinner for Scott in Burlington to pay tribute to him for his years as commissioner of agriculture. Instead, it turned into a political rally to push Scott for governor. And on February 6, Scott announced his candidacy and jumped into the race.

On May 2, 1948, the primary was held, and Johnson led the ticket as expected; however, he did not hold a majority of votes. Scott ran second, forty thousand votes behind. Because Johnson had not officially won, Scott asked for a second primary.

This time Scott waged a hard campaign, attempting to appeal to the farmers. He urged better rural roads, more electricity for farmers, more telephones and favored a state liquor referendum. One of the big things he threw into the fight was his discovery that state funds were being put into banks that paid no interest.

He carried his campaign to what he called "the branchhead boys." They were the farmers who lived way back in the country, up at the head of the branch, and those farmers liked Kerr Scott. Scott had helped them when he was agriculture commissioner, and when election day came, people who had never cast a vote in their lives went to the polls to vote for him. The branchhead boys helped him beat Charles Johnson by forty thousand votes.

He was the first farmer elected governor of North Carolina since 1893.

And when he took office, he did what he promised. He built more roads than anyone before, taking a lot of farmers out of the mud, giving them a better way to get their crops to market. Electricity and telephones spread across the state's rural areas, and the state's money started drawing interest.

When Kerr Scott was elected governor, he scored heavily with the farmers of the state. He often held big barbecue rallies on his Alamance County farm. Here he meets with supporters, young and old, at one such rally.

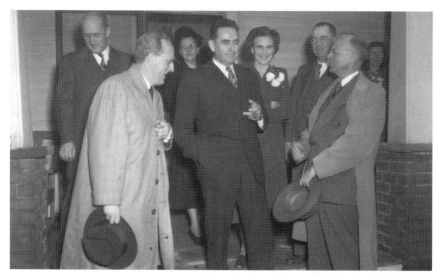

Kerr Scott had a wide base of support. Here he greets Kay Kayser (left), the famed bandleader of the 1940s and 1950s, at one of his rallies on the Scott farm. Kayser lived in Chapel Hill.

After his years in the governor's mansion, Scott captured a seat in the United States Senate and served there until his death in 1958. He came home on a Senate break in April of 1958 and died in a local hospital while at home.

ROBERT W. SCOTT

When Kerr Scott was governor, his son Robert was a student at North Carolina State University in Raleigh. Robert made no big thing about his dad being governor. In fact most of his fellow students did not know it. One spring night, Robert and some of his college buddies were riding around Raleigh and passed the back of the governor's mansion. Somehow they knew watermelons were there and Robert suggested they get one. Steal a watermelon from the governor's mansion? The others had doubts, but they agreed. They drove by, and Robert went inside and saw one of the staff members, who gave the governor's son a watermelon. He raced back to the car, and away they went, the others never knowing the truth.

Robert W. Scott, son of Governor Kerr Scott, followed his father in the governor's office twenty years later. He later served as president of the North Carolina Community College system, a system born during his years as governor.

After college, he went back to Haw River to run the farm while his dad continued his political career in the Senate. His father died in 1958, and Robert began to think more and more of politics. There were those who told him he should run for governor in 1964, and he considered it for a while. That was a long shot, however, and after careful consideration and talk with his advisors, the younger Scott decided to make a run for lieutenant governor.

During those four years, he made many friends in political circles all across the state, and when the 1968 election came around, he was on the ticket and made a successful run for the office.

Robert Scott was governor at a difficult time in the state's history. The Vietnam War controversy was raging, Martin Luther King and Bobby Kennedy were assassinated and there was rioting in the state's streets. There were several deadly situations, and there was one occasion in which he had to call the National Guard to duty in his home county. Rioting flared in Burlington over a controversy in the local high school regarding the election of cheerleaders. One young man was killed. The entire county was under curfew for two nights, and National Guardsmen patrolled the streets.

Robert Scott's years are remembered for much better things however, particularly in the field of education. Under his direction, the sixteen campuses of the state's university system were merged under one organization, the greater University of North Carolina. The state approved and put into reality the community college system, which opened new educational avenues for tens of thousands of North Carolinians, and the state began a publicly supported kindergarten program in every county in the state.

When he left Raleigh, Robert Scott spent time with the federal government, overseeing the agency that worked for the improvement of life in the Appalachian mountain region. However, he left that post to become president of the same community college system that he had helped form as governor. He served as its president for eleven years before retiring.

He went back to his Haw River home, adjacent to the Alamance Community College, for which his family had made land available. A collection of materials related to the history of the Scott family is now housed in a special library on the college's campus.

Tom Zachary

In the later years of his life, Tom Zachary got great enjoyment from doing a bit of farming at his home on East Harden Street in Graham. And he spent some time looking after the properties he owned around the county. He also took great pride in traveling the short distance to Chapel Hill, North Carolina, to watch his son Tommy play first base for the University of North Carolina Tar Heels. He was the quiet country gentleman in retirement.

Tom did not talk a lot about his earlier years and his career, nor did he submit to many interviews with the news media. He preferred his privacy. His friends and neighbors in Graham and surrounding communities respected this, remembering Tom's career with a bit of community pride.

Tom, you see, was a baseball player—a Major League baseball player—whose name will forever be etched in baseball history for a single pitch.

On September 30, 1927, Tom Zachary, pitching for the Washington Senators, threw a curve ball to Babe Ruth. Ruth hit it straight down the right field line and over the wall for a home run, so close to the foul pole that some still say it was a foul ball. That was Ruth's sixtieth home run of the season and a Major League baseball record that stood for some seventy years.

Zachary's date with history came in the eighth inning that day. The score was tied at 2–2. Yankee player Mark Koenig hit a triple off Zachary and brought Ruth to the plate for the game-winning, record-breaking shot. The Yankees went on to win the game by a 4–2 score.

It was a historic day, certainly, and there is another little-known piece of history from that same game: In the ninth inning, the Washington manager pulled Zachary for a pinch-hitter, the great Walter Johnson. He hit a long fly

ball, which Ruth caught in right field. That was the last time that the legendary Johnson played in a baseball game.

Tom finished that season with a 4–7 record. He started the next season in Washington and had a 6–9 record before being traded to the Yankees, where he had a 3–3 record to finish the season. He was then a teammate and roommate of the famed Ruth.

The next year, Tom made some history of his own when he compiled a record of twelve wins and no losses with the Yankees. That record of most wins without a loss was still intact when he died in 1969. It was an amazing record, but when people talked about Tom Zachary in later years, few mentioned that record. They always talked about the sixtieth home run pitch to Ruth.

Tom Zachary played nineteen seasons in the Major Leagues, and he compiled a record of 186 wins against 191 losses. Three of his wins came in World Series competition. He won twice in the 1924 series for Washington against the New York Giants. Then in 1928 with the Yankees, Tom beat the St. Louis Cardinals 7–3 with big help from Ruth and Lou Gehrig. Gehrig had two home runs, and Ruth added two hits. Tom never lost in World Series play.

Tom Zachary was born in 1896 in Graham into a devoutly Quaker family. He went to school at Guilford College, a Quaker school in nearby Guilford County. In 1918, he turned up as a left-handed pitcher with the Philadelphia Athletics. He was listed not as Tom Zachary, however, but as Zach Walton. Some said he used an alias to keep his identity from members of his Quaker family, while others said it was to maintain his college eligibility. He won two games with the Athletics with no losses.

Then he went overseas as World War I was ending and served not in the military but with a Quaker Red Cross unit. The Quakers were pacifists opposed to fighting.

When he came back to baseball in 1919, it was with the Washington Senators. He would stay there through the 1925 season when he was traded to the old St. Louis Browns, but in 1927 he was back with the Senators again, then with the Yankees. He later made stops with the Boston Braves, the Brooklyn Dodgers and finished his career in 1936 with the Philadelphia Phillies.

Tom then went back home to Graham. He never made a big thing of his career. However, he would sometimes play in the old-timer games, and he would attend some of the more important games during the season or for special events. And even after his death, Mrs. Zachary would get invitations from the Yankees to be on hand for old-timer games, and she would go to honor the memory of her husband.

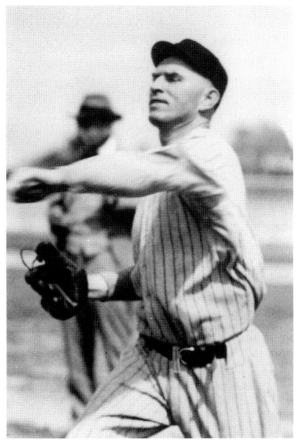

Tom Zachary spent parts of three decades playing Major League baseball. While pitching for the Washington Senators against the New York Yankees, Tom threw the pitch that Babe Ruth hit for his sixtieth home run in the 1927 season.

Hidden in the record books for the old Senators is the answer to another baseball trivia question that is relevant to Tom Zachary: "Who was pitching when the legendary Tris Speaker of the Cleveland Indians achieved his 3,000th hit?" The answer is the same Tom Zachary who threw Ruth that sixtieth home run. But the day Speaker got that hit, Tom Zachary won the game, unlike the day of Ruth's record homer.

Tom Zachary died on January 24, 1969, and he is buried in Alamance Memorial Park in Burlington with his wife and son, Tom Jr.

Burlington Mills

The year 1955 was one of transition for Burlington Mills: the textile company's name was changed to Burlington Industries, Inc., in order to encompass the broad scope of its activities, and it went on to become the largest maker of textile products in the world.

At that time, the Burlington empire included 75 manufacturing plants with 32,000 workers in 46 communities in 10 states and 3 foreign countries. Its sales in 1954 had totaled $347,494,000—almost $1 million per day.

Behind that picture of success was a story of thirty-two years of near miraculous growth and expansion.

The real beginning of the story was in 1919, the day that young James Spencer Love entered the textile business for the first time. He was just out of the army, having served as a major in World War I, and during his tour of duty he had been cited by General John Pershing for "meritorious and conspicuous service."

With $3,000 in army pay in his pocket, the twenty-three-year-old Love went to Gastonia, North Carolina, to look into the textile business his grandfather was operating. He took on the duties of paymaster in a cotton plant, but the $120 he received each month was not exactly the height of his ambition.

He decided to take his first big step in textiles, and with his discharge pay and $247,000 borrowed money, he bought the Gastonia plant. Love had not been operating the Gastonia mill very long before the bottom fell out of cotton prices, and he felt the full blow of the drop. His property, however, had become quite valuable, so he decided to sell out. He sold the mill buildings but kept the machinery. He had his mind set on moving to another location and starting again.

He began to look around for a new location, and a number of North Carolina cities beckoned to this young textile man. The offer that sounded best to him came

J. Spencer Love started a small textile mill in a cornfield in Burlington in 1923, a mill that would become the largest producer of textile goods in the world.

from the little town of Burlington. There the Chamber of Commerce offered Love funds sufficient for starting a plant for textile production. He arrived in Burlington and on November 1, 1923, met with members of the chamber. On that day, the new company was incorporated.

On November 8, 1923, a brief mention was made of the formation of the company in the *Alamance Gleaner*, a weekly newspaper in Alamance County. It read:

> *Through the efforts of the Burlington Chamber of Commerce, a big cotton mill is coming to Alamance. It was learned that a mill in Gastonia whose lands had become too valuable to be further used as a mill site had decided to move. The aforesaid Chamber of Commerce heard of it and went after it and got it. It has been operated successfully by Mr. J.S. Love who will come along and manage the new and enlarged mill to be built. The new enterprise has been incorporated as Burlington Mills, Inc., and will have capital stock of $750,000 to which the public will have an opportunity to subscribe in a few days.*

The first board of directors included Love; his father James Lee Love, a Harvard math professor; and a group of Burlington businessmen including D.E. Rhyne, J.L. Scott, M.B. Smith, D.E. Sellers, W.K. Holt, W.J. Graham and W.E. Sharpe.

The board went to work quickly to let contracts for construction of the mill buildings and cottages for workers. The first plant was built on ground that had only shortly before been a cornfield. Reports show that on July 29, 1924, the buildings and cottages were completed, inspected and approved.

With the new facilities ready, Love moved his machinery from Gastonia. Along with the machines came some of the more capable operators. They included C.R. Grigg, Jim Lovelace, Bob Hansell, W.E. Hartsell, Jesse Baker and two black helpers, Torrence Moore and Nathan Johnson. In addition, Love brought his first transportation department, a horse named Frank. Burlington Mills began production with two hundred employees to produce cotton dress materials, materials for railroad signal flags and a material used to make ladies' hats stiff.

Then the first crisis came to the infant company: Demand for the materials being produced by the mill simply dried up. Sales stopped. There was no profit in sight, and the organization faced liquidation. The board considered shutting down and going out of business, but the stockholders, headed by President M.B. Smith, found they would get only thirty cents on the dollar if they liquidated.

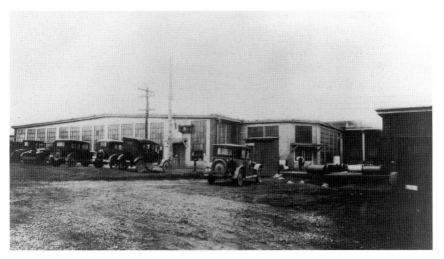

The first plant of Burlington Mills, the Pioneer Plant, was on Graham Street in Burlington. From this site grew a textile empire that at one time stretched across not only the United States but also the globe.

With everyone firmly against the idea of going out of business, Love came up with a new product: rayon. It was a cheap bargain basement material at the time, and many felt it both unsatisfactory and impractical. Love saw a potential in it, however, and he set up operations for weaving it.

The first products were bedspreads made of a mixture of cotton and rayon. The cotton threads ran up and down, and the cross filling was rayon, which gave the finished material a shine. The looms in the Burlington plant were not wide enough to weave the entire spread at one time, so the spread was made in two halves and sewn together in the middle. In simple terms, the spreads were terrible, stiff, streaky and almost fell apart when washed. Very few of them sold.

But Love would not quit. With the support of Burlington businessmen and their money he purchased wider looms and put men to work developing better rayon fibers. At the end of the first year, Burlington Mills used only 106 pounds of rayon, but it was a definite start in a field others feared.

The first move in the expansion of Burlington Mills came when the wide looms were needed for the bedspreads. Love borrowed needed money from Colonel Eugene Holt, Marvin B. Smith and Kirk Holt, and so formed Holt, Love and Smith, Inc. The spreads called for sewing and cutting facilities, so still another branch was formed, the Alamance Novelty Mills.

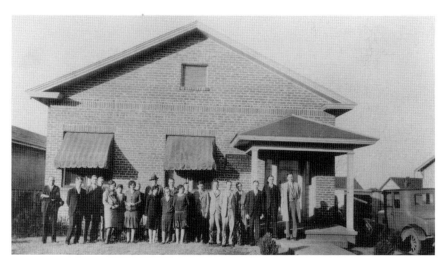

The office staff of Burlington Mills poses in front of the little office building that stood across from the first plant of the company. On the far right is J. Spencer Love.

Burlington Mills's first designer was a schoolteacher, W.E. Hartsell. He taught in Oakboro, North Carolina, and made designs in his spare time. These were mailed to the plant and an overseer used the designs to draw the warps for cloth weave designs.

New fields continued to open up for rayon products, and in 1927 North Carolina Silk Mills, Inc., was formed as part of the Love empire for the production of rayon dress goods.

By 1927 the company was on its way. Love's researchers had solved the problems of stiffness, shine and mottled dyeing to produce soft, pliant, dull-finished rayon. Instead of a cheap substitute for silk, rayon was now more desired by most shoppers than was silk itself.

Total sales in 1927 were $1,800,000, but Burlington Mills was still a "one-horse company." All its goods could still be hauled to the depot in a wagon drawn by a single horse. However, the sales showed Burlington was enjoying good corporate health.

Creating the mill had been a difficult process, but from the shoestring start in the cornfield, Love had played his cards with the genius of a wizard. He had borrowed every inch of the way, but he always had his ace in the hole. When he began to form new companies, he made sure to keep one of the companies in the black with a respectable balance sheet. He did this to get credit on the solvent company with which to nurse newly created units through their infancy.

During the Depression years, things looked bleak for industry all over the nation. Burlington, North Carolina, was the exception. Burlington Mills seemed to thrive on the failure of other mills. It has been said that "God and good management" were on the side of Burlington because as other cotton mills closed, Burlington Mills was able to buy them and put in new machines and produce more rayon goods.

In 1932, with businesses closing all around, Burlington Mills consumed ten million pounds of rayon, and its twelve North Carolina plants enjoyed sales totaling $15,000,000. In 1933, the year of the bank holiday, Burlington had some four thousand employees. All those workers enjoyed a 15 percent salary increase that year, and they turned out sixty million yards of fabrics.

The next year, just ten days after New Year's Day, Burlington Mills was recognized as the largest weaver of rayon fabrics in the United States, a position it still held in 1955. The field in Burlington had truly produced gold instead of corn.

By 1935, many older and more firmly established mills continued to close under the financial stress of the Depression. Still, Burlington Mills continued to buy, refit and open new plants, and a New York company was formed to handle the growing sales. Burlington's sales hit $20,000,000 that year.

Tales of Railroads, Textiles and Baseball

At the end of 1936, Burlington Mills had grown to include twenty-two plants in nine communities, with a production sales total of $25,000,000. Burlington was continuing to grow rapidly, and the eye was always on the future. New buildings went up to house new machinery, and by examining one of the buildings, it was easy to see the future planning of the Love empire.

When Burlington Mills put up a new building, the ends were only temporary wooden walls. The end walls were of wood for the single purpose of knocking them down later and adding to the building. Expansion was built in from the beginning.

By 1937, all plants were solvent and orders were beyond capacity. That year also marked the first appearance of the company on the New York Stock Exchange. Stock was offered to the public, and the little Burlington cornfield began paying dividends. The first dividend was paid in May 1937, and by July the stock was selling for $18.25 per share. Burlington Mills had officially come of age as a national institution.

With 1938 came a new field for Burlington's man-made yarn. Burlington entered the hosiery field that year, and in 1940, the first spun rayon division was established. This new division made possible the production of a wider variety of dress and suiting materials. That same year, two spinning mills were added to meet the company's ever-increasing demand for yarns.

In 1941, the forty Burlington Mills plants had sales totaling $63,000,000. Then in 1942 it was revealed that Burlington Mills was the single largest purchaser of rayon yarn in the United States. The number of plants had grown to forty-four and the company employed sixteen thousand people.

With the coming of World War II, Burlington Mills turned to production of war materials. Fabrics for more than fifty war products were produced in Burlington plants. Fabrics were made for parachutes, uniforms, tents, raincoats, airplanes, gun covers and tow targets. Spencer Love, then chairman of the board of directors, went to Washington to head the Textile, Clothing and Leather Division of the War Production Board.

A total of 4,009 Burlington employees served with the armed forces, and 109 gave their lives in that war.

Even with production turned to the war effort, the facilities and reputation of Burlington Mills continued to soar. The wooden walls continued to fall to make way for bigger and better plants. This expansion was no longer confined within the borders of the U.S., as operations were begun in Cuba, Australia, Mexico and Canada.

Rayon was now *the* thing. Once a cheap substitute for silk, rayon had outsold silk by six to one as early as 1937, and the demand was continually growing because of Burlington Mills.

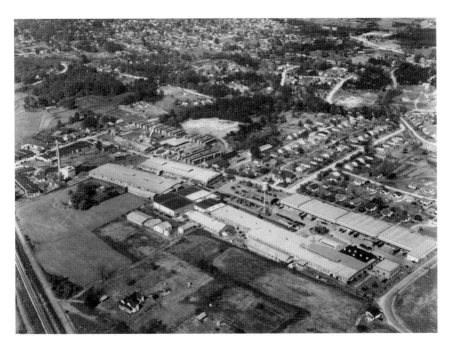

Burlington Mills Pioneer Plant is seen in an aerial photo made in the 1940s, showing the plant with the surrounding community.

Burlington Mills continued to soar to the top under the guidance of President Love and Vice President and General Manager J.C. Cowan Jr. Cowan was one of the many men who worked up through the ranks of the company. He began as superintendent of the Ossipee Plant near Burlington in 1931. He moved to the executive ranks in 1935.

With no end in sight, the Burlington story continued to grow. A new field was tapped in 1945 with the purchase of a number of ribbon plants. Reidsville, North Carolina, became the central office for the ribbon division with other plants in South Hill, Virginia, and White Sulphur Springs, West Virginia. The division became one of the biggest producers of ribbon in the nation.

The little Burlington cornfield continued to yield a bountiful harvest. In 1946, Burlington Mills moved into South America with a plant in Colombia. When figures were in that year, they showed sales had topped $144,000,000 and the number of employees had risen to 23,000. Then the Cramerton Division was added in 1946. That plant insured greater diversification in the production of all cotton and rayon blended fabrics.

The next big step came in 1948 with the acquisition of May-McEwen-Kaiser Hosiery Company in Burlington, which marked Burlington Mills's greatest expansion in the hosiery field.

By 1948, Burlington had established its own converting operations in order to sell more goods in the finished state to apparel manufacturing and retail trades. The Wake and Altavista Finishing Plants were completed, and many additions and improvements were made to existing plants. The quality and research laboratory was tripled in size to meet the needs of the ever-widening line of Burlington products.

Wooden walls continued to fall in 1950, and a multi-million-dollar plant improvement program was begun. Controlling interest was acquired in Brighton Mills in Shannon, Georgia, as well.

Still another new area was entered in 1952 with the purchase of Peerless Woolen Mills. That put Burlington in wool for the first time. The Peerless plant was the largest of its type in the nation, with a single plant handling wool from purchase of raw material to sale of finished goods.

In 1954, Burlington bought controlling interest in Pacific Mills, makers of towels, sheets and other cotton products. Goodall-Sanford Company, maker of Palm Beach suits, also came under Burlington control. Expansion continued in 1955 with the purchase of Mooresville Cotton Mills, an action that set off a celebration in the streets of the North Carolina town.

On February 4 of that year, the worldwide company became known as Burlington Industries. The Burlington *Daily Times-News* carried this report of the change:

> *Stockholders of Burlington Mills Corporation at their annual meeting held today approved changing the name of the company to Burlington Industries, Inc. as a new designation for the overall parent company embracing Burlington Mills and the aggregate of its affiliated and subsidiary companies.*
>
> *Burlington Industries, Inc., will serve as the parent company of Burlington Mills, Burlington Hosiery, Galey & Lord, Peerless Woolens, Burlington Decorative Fabrics, Mallison Fabrics, Pacific Mills, Goodall Fabrics and Burlington International.*

The board of directors said the name change was made because the new name would be "more descriptive of the company's current policy of decentralization and its expanded range of diversified operations."

At that point, Burlington was a name known the world over. The company led the world in the production of ladies' hosiery and was near the top in men's half hose and children's socks.

Burlington also led the world in production of ribbon, and its fabrics were found almost everywhere in lingerie, dresses, suits, hosiery, underwear, work clothes, seat covers for automobiles, draperies, curtains, bedspreads and much more. Some said at the time it would be hard anywhere in the United States to go through a day without coming in contact with a Burlington product.

The company had long operated its own fleet of trucks and by 1955 had a fleet of four aircraft. Some said in 1955 that if Burlington's trucks stopped for ninety hours, the nation would stop too. That may have been an exaggeration, but the nation certainly would have felt a major blow.

The Burlington story went on from 1955, soaring to the top of the textile world in many areas. The good years continued even after the death of Spencer Love, but as the twentieth century wound down in an era of textile competition from abroad and stock buyouts, Burlington Industries faded into the past. The remnants of the company, along with the remaining operations of another North Carolina textile company, Cone Mills, have been combined into a new operation, International Textiles. Burlington Industries, however, is a name that will never be forgotten when great industrial success stories are written in American history.

A Snowstorm to Remember

Every winter when there is a prediction of snow, the questions begin: "What year was it that we had that record snowstorm?" There is usually some argument about the answer, as one person believes it was this year, while another believes it that year.

The answer is 1940. Indeed, that year had a record storm, not only in the amount of snow that fell but also in the temperatures that came in the wake of the snow. Old-timers still talk about the storm today.

January of 1940 was a severely cold month for much of the nation. On January 20, the *Daily Times-News* reported that a cold wave was moving across the southern part of the nation. People were reportedly ice skating in Louisiana, and temperatures were well below freezing in Florida. Bitter cold was being felt from the Rockies to the Atlantic coast.

Three days later, a snowstorm moved into the Piedmont area of North Carolina, beginning about 10:00 a.m. in the Alamance County area. The weather bureau reported that this snow could last up to twenty-four hours, and residents could expect as much as four inches.

By 9:00 p.m., the snow was continuing to pour down, and the area's public buses stopped running. Streets were becoming blocked with snowdrifts. The snow continued to fall far into the night, finally ending about 4:00 a.m., and on January 24, Alamance County awoke to one of the worst snow accumulations in its history.

The headline across the top of the *Daily Times-News* read: "Winter's Worst Snow Storm Visits North Carolina." Schools were closed, the mail was delayed and traffic was at a standstill. The accumulation reached eighteen inches, according to the newspaper report, but later reports indicated the level was more like twenty-four inches over most of the county. The snowfall was the heaviest since the big

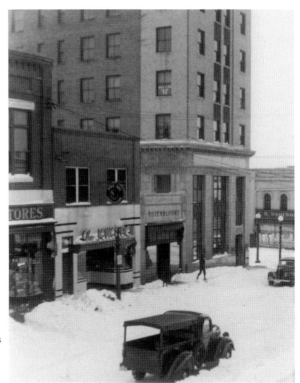

As January 1940 neared an end, one of the worst snowstorms of the century hit Alamance County. The snow piled up twenty inches deep in many places and drifted five and six feet. This is Main Street, Burlington.

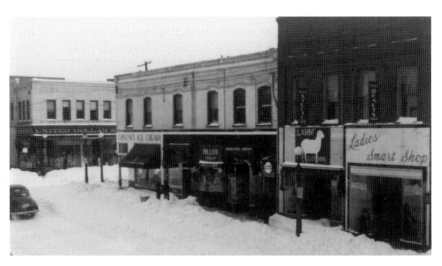

Businesses in Burlington remained closed after the 1940 snow hit. Traffic was at a standstill. This scene shows no sign of activity. In the wake of this storm, temperature dropped to a record negative twelve degrees Fahrenheit in Alamance County.

storm of 1927, surpassing that storm by at least three inches. Drifts of five and six feet were reported.

Alamance County was crippled. Businesses could not open. People could not get to them to open. The textile mills were closed for the same reason.

In Graham, the roof of Green and McClure Furniture Store collapsed, creating a total loss for that firm. In Burlington, the roof of Spence-Clapp Motor Company in the downtown area collapsed under the weight of the snow. The newspaper reported that the roof fell in on the "10 best used cars" at the business.

The three local hotels were filled to overflowing because travelers had to seek refuge from the storm.

On January 25, the city was rushing to get streets open so businesses and mills could reopen. The city had forty-seven miles of streets to clean. A crew of more than one hundred men was brought in to move snow, and they soon had all main roads at least passable. Buses still remained off the streets and would for another day.

School officials decided to call a holiday until the following Monday, January 29, as roads in the county were still covered, and no school buses could run.

One business that did remain open through it all was the Graham Theater, a movie house. There was no report regarding attendance.

The snow also brought some of the lowest temperatures ever to the state. On January 26, the mercury dipped to seventeen degrees below zero in Asheville, the lowest ever recorded in the state, according to news reports.

In Alamance County, activities were returning to normal, but it was still difficult to travel. Dr. C.C. Lupton tried to answer a call in his car and ended up in a snow bank. He had to get a horse and buggy to carry him to his patient.

The next day, the temperature hit eighteen below zero in the mountains for another record, and the French Broad River froze over for the first time since 1918.

Here in Burlington, kids were skating on ponds that had never been frozen before. On January 28, the temperature fell to negative twelve degrees at Burlington's Stony Creek reservoir just north of town. Readings of negative six degrees and negative eight degrees also occurred during this period.

A new announcement on schools on January 27 moved the opening back to January 31, as Dr. L.E. Spikes, superintendent, described conditions here among the worst in the state.

Gradually, the community thawed out and things returned to normal. For those who were living here then, however, the memory never faded. The 1940 snowstorm is the one by which all others are compared.

The Day the World Changed

December 7, 1941, dawned cold and clear in Alamance County, a Sunday morning typical of late fall.

But before the day ended, the lives of every person in the county would be changed. No one realized it, but while they were preparing for church, there were planes over the Pacific Ocean, headed for a place that few people knew existed but would live in history from that day forward.

Pearl Harbor meant little to most people in Alamance County, but it would be well known shortly as the Japanese were about to unleash a surprise attack on the American naval base there.

Most people were looking ahead to Christmas, with decorations already out in the area.

Elon College had opened its basketball season on Saturday night, but it was not such a good showing. Elon bowed to Georgetown University by a 49–44 score. The Elon High girls had a better time of it, whipping the Burlington High girls 39–6 in a preliminary game.

Bob Hope was starring in *Nothing But the Truth* at the Graham Theater, and the Salvation Army had reported that it had located its kettles around the county to collect money in order that less fortunate residents of the area could have Christmas cheer.

Readers of the *Daily Times-News* had gone to bed on Saturday night after reading that the German army was advancing on Moscow and that the Russian capital was in danger of falling to the Nazis. They also read that the "Far East Crisis Hangs in the Balance." Little did they realize that within hours that balance would tip, and the world would be plunged into World War II. The difference with Japan had been widening for the past year, and

war had been a possibility. No one here, however, realized it would come so soon and without warning.

Sunday, December 7, 1941, was a tragic day in other ways for Alamance County.

Two county residents were killed in an auto crash near Sedalia in Guilford County. Here in Alamance County, a grinding crash at the railway underpass in Glen Raven killed four people instantly and injured several others. More than one thousand people were said to have gathered at the scene.

Members of the Alamance County 4-H clubs came home on Sunday with top honors from their state convention, and the Elon College music department presented its annual program of *The Messiah* on the college campus.

It was shortly after 1:00 p.m. that Alamance County received the news.

The Japanese had bombed Pearl Harbor, and the United States was at war.

The attack occurred just as many people were finishing lunch.

"Where is Pearl Harbor?" was the first question of many here. A few knew its location. There were some local young men serving at the Hawaiian base that morning, but none was among those reported killed.

People huddled by their radios and listened to the news that was certainly not good. The giant battleships of the Pacific fleet were in the harbor for the weekend. Early word was that most were disabled or at the bottom of the harbor. It was a bitter defeat, but it was not as bad as it first sounded. All those ships would soon be back at sea and in the fight—except for the *Arizona*.

The next day Congress declared war on Japan, and there were reports of enemy planes over California, although the information was false. War would be declared on Germany and Italy on December 11.

Monday found the first Alamance County men volunteering for service, and in the time before the war ended in 1945, more than five thousand Alamance County men and women would serve in some branch of the armed forces.

Of those who served in the army, ninety-eight were killed in action, thirteen died of wounds, thirty-nine died of causes other than battle injuries and two were listed as dead after having been listed as missing in action. Casualties for other branches of the service pushed the total number of dead to more than two hundred.

For those who stayed home, there would be many changes in their lives. Gasoline and tires would be rationed, along with many different food items on the rationing list. Banks, schools, post offices, factories and businesses would have concerted efforts to sell war bonds and stamps.

Industrial plants turned their production to the war effort, with local textile plants producing materials for uniforms and other war needs. The hosiery industry suffered a blow when the government took all of the new synthetic fabric, nylon, for war purposes. Nylon made great parachutes, and the ladies had to do without nylon hosiery for the duration.

The old Rayon Plant was converted to an airplane factory for production of a training plane, and many people came here from the Fairchild plant in Hagerstown, Maryland, to work. An entirely new housing community was built near the plant for the new workers.

Uniforms would become common on the streets of area communities, and there would be a USO center set up in downtown Burlington for the benefit of service personnel stopping over in the city.

Alamance County would change, but no one knew to what extent on that Sunday morning. What had dawned as a peaceful autumn morning ended in tragedy, with a single event reshaping the lives of everyone in the county.

In the years that lay ahead, Alamance County residents would become familiar with such places as Midway, Anzio, Casino, Omaha Beach, Okinawa, Iwo Jima—and Alamance County residents would read about most of those places under fire.

After that calm Sunday morning, the day turned to one of anxiety, emotion and fear, a day that would live in history, a day marked by President Franklin D. Roosevelt as "a date which will live in infamy."

Alamance County's Biggest Fire

It was 6:16 a.m. on Sunday morning, December 20, 1942, when the Burlington volunteer fire department received a call. An oil stove had exploded at the Barnwell Brothers trucking facility just east of Burlington. Volunteers responded to the alarm, but before they could get their truck moving, there came a second call. The fire was spreading rapidly, and all the fire equipment possible was needed.

A call immediately went out to Graham, and both Burlington and Graham firemen responded, Burlington with two trucks, Graham with one. Little did the firemen know what awaited them.

There was a heavy wind that morning, and when the fire equipment rolled onto the scene, the sight startled the firemen. It was a fiery holocaust, flames boiling into the sky over the big terminal, and trucks ablaze in the yard. A large local trucking operation, housed in buildings called the most modern trucking facilities in the South, was engulfed in flames. The main building, located just a short distance east of downtown Burlington and just north of Graham, had been built only three years before.

The business had its start in 1929, formed by three local brothers, and it would soon begin to transport products produced in the area's textile mills to the markets in New York City and other points north.

James A. Barnwell and his two brothers, R.W. and John, formed the Barnwell Warehouse and Brokerage Company. In 1930, the firm expanded and became Barnwell Brothers Trucking Line.

There was just one vehicle in the beginning, a GMC truck that was first used by James Barnwell and Robert Preddy to move a load of textiles from Burlington to New York. Early operations were designed to transport textile yarn from New

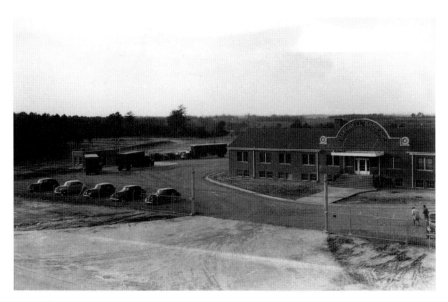

Barnwell Brothers trucking terminal was one of the most modern in the South in 1942. The company had grown from a one-truck operation to a place of prominence in the industry when fire struck in December of 1942.

York where it was imported from Germany. Just sixty days after operations began, the flow of goods was restricted by import laws and yarn shipments ceased.

That's when the Barnwells began to move freight north with great success. An operation that began with one truck soon grew into a major business providing valued service to the textile industry in Alamance County.

The terminal had been located in what seemed to be a perfect location. It was near the middle of the county, located right on Highway 70, the main traffic artery across North Carolina. It was that location, however, that was a major problem on that December morning. The terminal was located outside the city limits of Burlington, and because of that, there was only a single fire hydrant from which firemen could draw water. That was hardly enough to do any good, and water from that single hydrant was used to try to save some of the burning trailers.

Some of the company's 250 employees soon heard of the fire, and they rushed to the terminal to help in any way they could. Drivers went into the inferno and drove trucks, some of them afire, to safer areas.

That was in the early days of World War II, and just about all the goods in the terminal were in some way related to the war effort.

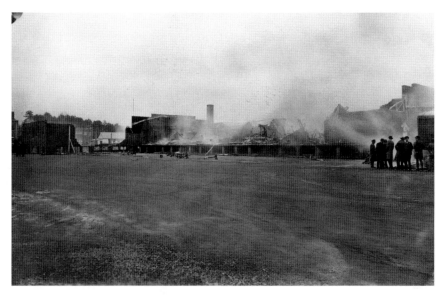

The Barnwell Brothers terminal was a total loss when the flames were extinguished. Many goods for the war effort were in the terminal at the time, and the loss was the largest fire loss to date in Alamance County.

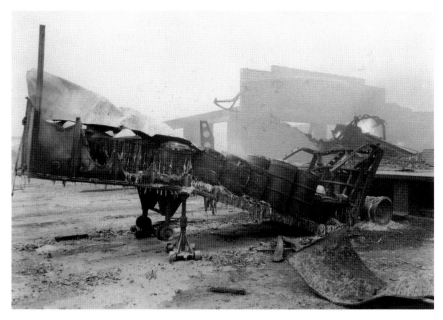

Many tractors and trailers were destroyed in the 1942 Barnwell Brothers blaze. Some drivers risked injury to go into the fire and drive trucks away.

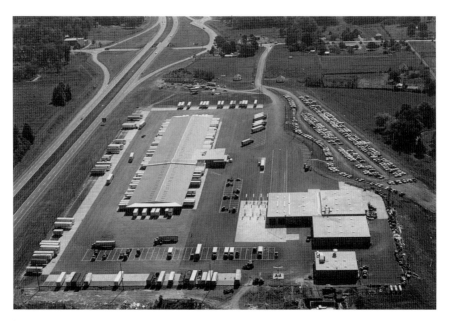

Barnwell Brothers came back quickly, having merged with Horton Motor Lines and other smaller firms in 1942 to form Associated Transport. That company moved to this terminal on Interstate 85 in Alamance County. The company ceased operations in 1976.

At least two trucks were loaded with explosives, but drivers pulled them to safety, preventing what company officials said certainly would have been heavily destructive explosions. One truck was loaded with coffee, and the next day when most of the fire was out, the coffee was still burning and smoldering.

Grover D. Moore was fire chief in Burlington, and he called in every volunteer he had, along with a number of auxiliary firemen. From Graham, Dr. Will Long led his fire crew into the blaze. Dr. Long went to church later that day, his white moustache still blackened by the smoke of the morning's fire.

When the fire died down, there was little left of the office and terminal area. There were fourteen offices in addition to the main office destroyed, along with all the loading docks and many trucks. Some of the trucks were nothing more than shells, with the tires burned off and the cabs and trailers gutted.

Before the fire was out, however, plans were being made to continue company operations. Office space was found in the Atlantic Bank and Trust Company Tower, and storage and transfer operations were set up in a local tobacco warehouse.

Luckily, most of the estimated $500,000 loss was covered by insurance, which at the time was the most destructive fire ever to hit Alamance County.

Barnwell Brothers joined Horton Motor Lines and five smaller carriers to become Associated Transport. That firm became one of the leading motor transport lines in the nation. The terminal on North Church Street was rebuilt after the 1942 fire, and it served for many years as the Associated site.

In 1965, the company operated in thirteen states and had three thousand units on the highways. It was then that the operation moved to a new and ultramodern terminal on Interstate 85 on the south side of Burlington. The company continued to operate there until 1976, when it fell on hard economic times and closed its operations. That location later became a major shopping center.

The rebuilt North Church Street site still exists today and is used as a storage site for a moving company.

The Big Years of Baseball

The many textile mills and hosiery plants in the Burlington area in the 1920s and 1930s did more than provide employment for much of the population. They brought baseball to the community, and the rivalries between the teams were as avid as anything in the Major Leagues.

Almost every mill had its own team with its players known as semi-professionals. The players were hired to work in the mills, but in truth, some of them were hired more for their skills with a bat than their ability to operate a loom. Great competition developed, especially among the bigger mills, and it was not uncommon for an outstanding player to get an offer of a better job from a crosstown rival. Of course, he would have to play baseball there too.

There were some very good players on the semi-professional teams, and some of them moved on to play professional ball. A few actually made it to the Major Leagues.

There were a lot of small baseball fields around the county, but the major location for the game in the early years was Hillcrest Park. It was located behind Hillcrest Elementary School, and while it served that school's recreational needs, the local high school also played its baseball and football games there.

Semi-pro baseball was at its peak in the early 1940s. At one time, there were fifty-five amateur or semi-pro teams in the county, and it was during that time that some of the top stars in Major League baseball history came to the little Hillcrest Park to play.

During World War II, the U.S. Navy had a pre-flight training program at the University of North Carolina in Chapel Hill, some thirty miles east of Burlington. The navy unit had its own baseball team, and it was filled with stars, the biggest of whom was Boston Red Sox star Ted Williams. On two occasions, that team came to the Hillcrest field to play local semi-pro teams, and the team included not only

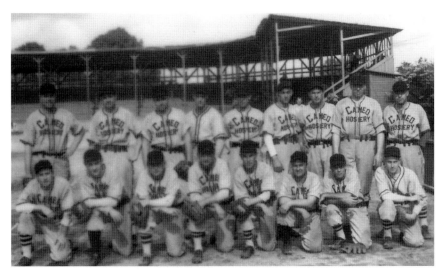

Hillcrest Park was the main baseball field in Burlington in the 1930s and 1940s. A team representing Cameo Hosiery is in front of the grandstand. Players were on the mill payroll, but one of their main jobs was baseball.

Williams but also Johnny Pesky of the Red Sox and Major League pitcher Johnny Sain. The Navy team won both games, although not by huge margins.

In the years following those games, accounts of the events on those two days became a bit tainted by legend. The story grew that Williams had hit the longest home run ever hit in that park. In truth, he did not hit a homer in either game. Box scores found in the local newspaper show that he did have hits in both games, but he did not hit a home run.

The big success of semi-pro baseball led some local enthusiasts to form a professional team in the old Bi-State League in 1942. However, the league folded the next year because of the war. Then as World War II ended and travel restrictions were lifted, Burlington's team entered the Carolina League with other teams in North Carolina and Virginia.

The team, nicknamed the Bees, played its games in the old baseball park at nearby Elon College. By 1947 the Bees had put together a very good team and attendance soared. In that year, the Bees attracted more than 140,000 fans for the season.

In those days, minor league players stayed with their teams for several years in many cases, unlike the situation in farm systems in later years. The Bees were managed by Buddy Bates, who also played center field.

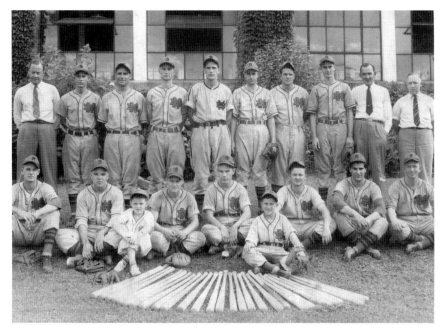

Burlington Mills's semi-pro baseball team was one of the top teams in the state in the late 1930s and early 1940s. At least two of these players later played in the Major Leagues.

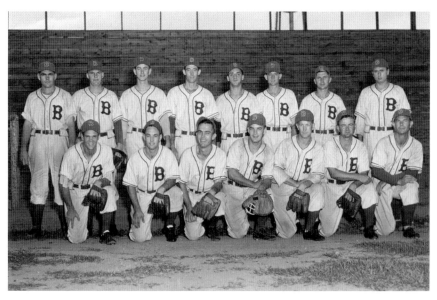

The Burlington Bees were one of the early professional teams in the area, winning the Carolina League championship in 1947.

Tales of Railroads, Textiles and Baseball

One of the biggest players to come through Burlington did not stay too long, however. He was Gus Zernial. Gus was a slugger. He led the league in home runs and then quickly moved on to the Majors with the old Philadelphia Athletics. Gus had a long career with several Major League clubs before retiring. He is still well remembered by many of the area's old-time baseball fans.

In the late 1940s, it was not unusual for two or three thousand fans to turn out for a game, and the little Elon park was often overflowing. Those who arrived for an 8:00 p.m. game later than 6:30 p.m. might find themselves sitting on the grass just inside the outfield fence. The outfielders then had to be extremely careful when chasing fly balls to the wall.

The fans turned out to see Zernial and others like Ken Deal, Tom Saffell, Larry Hartley, Max Wilson, Tal Abernathy, Pete Howard, Johnny Clayton and any number of other stars.

There were great rivalries there as well, especially with the nearby Greensboro Patriots. The Patriots had a slugger named Emo Shoferty, and he was hated by local fans. When he was later traded to the Bees, he immediately became a hero. Loyalties also went the other way when Buddy Bates went to manage Greensboro, but those twists and turns were the things that made the game so much fun for the fans.

As the years passed, the Bees became a farm team for the Pittsburgh Pirates and moved to a park in Graham to become the Bur-Gra Pirates. It was during those years in Graham that a young player named Ron Necchi came to the team. He came up from the team in Bristol, Tennessee, where he had amassed an unbelievable strikeout record.

Necchi struck out twenty-eight batters in a game there—every man he faced. He had to face one over the limit of twenty-seven, because the catcher dropped the third strike and the runner reached first safely. He attracted huge crowds to the local park before moving on to Pittsburgh in quick fashion. His time there, however, was quite short, as he developed arm problems.

Another young player who appeared in Graham was a young catcher from New Jersey named Jack McKeon. Jack would later turn to managing and would become one of the best-known managers in Major League history. He had stints at Kansas City, San Diego and Cincinnati, and was general manager in a couple of places as well. Jack made many highly publicized player trades and gained the nickname Trader Jack.

While in Graham in his early years, he met and married a local girl, Carol Isley. They have made their permanent home in the area ever since. Jack also graduated from Elon College here while carrying on his baseball career.

In 2003 Jack was in retirement here watching his grandkids play high school ball when a phone call from the Miami Marlins suddenly thrust him back in the game. He joined the Marlins as manager and went on to win the National League playoffs, then won the World Series by defeating the heavily favored New York Yankees.

The local professional team later moved to Burlington and played at Fairchild Stadium. Declining attendance led to the end of baseball here for several years, but it was revived in 1986 with the return of a Cleveland farm team that plays in the Appalachian League, a league for rookies who play a shorter season than other leagues.

Fairchild Builds Planes in Burlington

Although the first flight of a powered aircraft was made in this state, North Carolina has never been known for the manufacture of airplanes. There was a brief time during World War II, however, when several thousand people in the state were engaged in the production of an airplane for the military, an airplane that was most unique in construction, but one that was destined to be forgotten quickly. And it was built in a plant that itself has a storied past.

The war was but two months old when the federal government's Defense Plant Corporation bought a vacant textile building in Alamance County and leased it to the Fairchild Engines and Airplane Corporation on February 17, 1942.

With the outbreak of war, the Air Corps had a severe need for training planes in order to teach crews for the nation's bombers. In the year prior to the war, this shortage had been envisioned, and the call went out for a new training plane. But there was a major problem—the aluminum needed for the construction of such a plane was a scarce commodity in the wartime buildup.

Fairchild had earlier built the PT-19 primary training plane of wood and steel-tubed construction, and they also had built a civilian plane using a patented process they called Duramold. That was a process of wood laminating that eliminated the need for aluminum. It was a process of bending wood, synthetic rubber and fiberglass to make various shapes and curves. That was the same process Howard Hughes used in 1946 to build a gigantic plane that became known as the *Spruce Goose*. That plane flew only a few minutes and is now a tourist attraction on the West Coast.

When the army issued the call for a new training plane, Fairchild proposed the molded aircraft. The first prototype flew in mid-1941, but testing showed it needed a lot of work. Revisions were made, and the AT-21 Gunner was born. Fairchild Aircraft Company built the twin-engined plane for the army in a converted textile

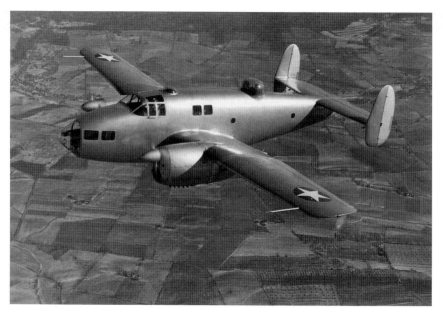

In World War II, Fairchild Aircraft built a twin-engined training plane for the military in Burlington. An old textile plant between Burlington and Haw River was bought by the government and used as the plane factory.

plant in Burlington from 1942 to 1944, and it was used to train crews for B-25 and B-26 twin-engined bombers.

The plane's uniqueness lay in the fact that it was constructed almost entirely of molded wood. The only non-wood parts in the most significant areas of the plane were in the landing gear, engine mounts and fire walls. The construction process made an ultra-sleek exterior surface, and that gave the plane a higher performance level than planes of higher horsepower. The fuselage had wooden bulkheads covered with molded veneer skins, and an internal tube truss. The wings had wooden spars with truss ribs, covered by Duramold skins. It had a tricycle landing gear and twin rudders.

The AT-21 had two 12-cylinder Ranger air-cooled engines with 520-horsepower each. It had a top speed of 210 miles per hour and a range of 736 miles. Its wingspan was 53 feet and was 37 feet 7½ inches long.

Fairchild was given a contract for 106 of the planes. Fairchild contracted with two other airplane manufacturers, Bellanca and McDonnell, to build some of the planes. Bellanca built 39 and McDonnell constructed 30 others. Fairchild's

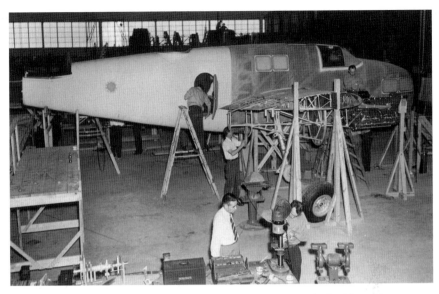

A plane in construction in the Fairchild plant in Burlington. It was built with a unique process using almost entirely wood. Howard Hughes later used this same process in building his huge craft known as the *Spruce Goose*.

A huge crowd turned out to see the first plane fly at the Fairchild Airport adjacent to the plant. North Carolina Governor Melville Broughton was the featured speaker for this event.

operation was set up in Burlington. There were problems, however, in the fact that the region lacked the skilled woodworkers needed for the plane.

The call went out for workers, and they came to Burlington from distant points, many of them from Fairchild operations in Maryland. The sudden influx of workers created a need for housing, and an entirely new village was constructed in the area just north of the plant. It was known for many years as Fairchild Heights, and the land is now occupied by Eastlawn Elementary School and the administration offices of Alamance-Burlington Schools.

There were many delays in production because of the search for skilled workers, and many had to be trained. Because of this and other problems, it was not until May of 1943 that the first plane flew from the Burlington plant. An airstrip adjacent to the plant, Huffman Field, had been taken over and improved, and it was at that field that more than fifteen thousand people turned out that day in 1943 to see the plane tested. North Carolina Governor J. Melville Broughton was the speaker for the event and another special guest was Adolphus V. Drinkwater of Manteo. He was the reporter who forty years earlier had flashed the message that the Wright brothers had made a successful flight at Kitty Hawk.

Once Fairchild had the contract, the company received a $3 million loan from the Reconstruction Finance Corporation and made extensive improvements to the old textile plant. The aircraft factory changed Burlington and Alamance County forever. It brought a huge immigration of workers from distant areas, including people with different cultural backgrounds. Many of those people made their homes in the area on a permanent basis, thus altering the solid Southern Protestant structure on which the community had grown.

Many of those workers who moved into the plant were women. As was the case in defense operations all across the nation, women did jobs that in the past had only been done by men. They worked on the assembly lines, installed engines, tested landing gears and worked on any other job that was needed. They filled a huge gap created by the fact that so many men in the labor force were called into the military. But there was no Rosie the Riveter in this plant: the wooden plane had no rivets.

Women also took many jobs in the community that were vacant because of so many men being in the military. It was the first time many of those women had worked outside the home. The real impact of that change came after the war when so many of those women decided to remain in the workforce. Community and family life would never again be as it was before the war.

Tales of Railroads, Textiles and Baseball

The plant in which the AT-21 was constructed has an interesting story of its own. The original building was constructed in 1927 for A.M. Johnson Rayon Mills, Inc. The company produced the new synthetic fiber: rayon. The owner, A.M. Johnson, was from Chicago, Illinois, and he was president of the National Insurance Company. He was quite wealthy, and he built a home in Death Valley, California, which today is still a major tourist attraction. It is a part of the National Park Service and is known as Scotty's Castle, named for the eccentric old man who lived there for so many years and cared for the property for Johnson.

In 1929, a second and larger A.M. Johnson Rayon Mills building was constructed at the Burlington site, but the company had little success. It had a major competitor in Burlington Mills, just a few blocks away. Johnson's mill was reorganized in 1930 as Carolina Cotton Mills, but it failed quickly and was closed in 1931. It stood vacant for the most part until Fairchild arrived in 1942.

Fairchild built planes there until October of 1944. But almost as soon as production had begun in 1943, the plane's fate was sealed. The Air Corps changed its training programs. Most of its air operations then had moved to bigger four-engined bombers, the B-17 and B-24, and it was found that it was easier to train crews by putting them directly into those planes rather than trying to teach them in smaller planes like the AT-21.

As a result, the AT-21 became obsolete, and Fairchild halted its operations.

Problems with the plane itself might also have been part of the reason for the demise of the AT-21. Some who flew it said the plane really proved unsuitable for the purposes for which it was designed: gunnery and bombardier training. A pilot who trained cadets in the plane said the short distance between the gull wing and the twin rudders created problems in flight. There was an unacceptable yaw with only the slightest movement of the rudder, he said. Other problems included poor single engine performance and landing gear issues.

On October 18, 1944, one of the AT-21 gunners was on a flight from Dover, Delaware, to Wright Field in Ohio. The plane caught fire and crashed into the Delaware River, killing all five airmen aboard. After this disaster, production was stopped.

However, the old textile plant, known by Burlington's older residents as "the rayon plant," found new life. Firestone occupied the property and began building ninety-millimeter cannons and fifty-seven-millimeter shells in the old aircraft bays. That work continued until the day in August of 1945 when the Japanese surrendered. The order came from Washington to stop work that very day, and the plant was closed.

After World War II, Western Electric came into the Fairchild plant. WE first produced telephone equipment, but later most of the work was done for the military. At peak production, Western Electric had some three thousand employees in the plant.

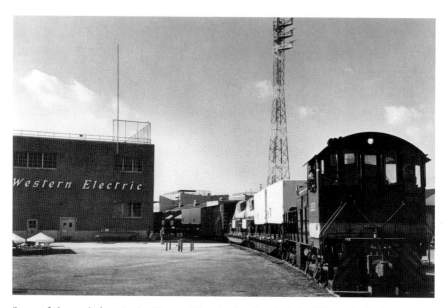

Some of the work done in the Western Electric plant involved the Nike anti-missile system for the military. Much of that work was secret, but passersby could often see trains with anti-missile radar equipment at the WE site.

Still, the old plant would not die. In March 1946, Western Electric Company leased the plant from the General Services Administration for the manufacturer of commercial electronic equipment, including telephones.

However, the plant was not yet through with military work. Western Electric began producing gun directors for the U.S. Navy, and by 1951, there was little civilian equipment manufactured there. Several new buildings were constructed, and by 1953 the plant was used in the testing and assembly of the army's Nike Ajax guided missile system. Manufacturing moved from the Ajax to the Nike Hercules missile guidance components and then to the Nike Zeus system. It became a common sight during the height of the Cold War to ride by the plant and see the radar units atop the buildings rotating as tests were being performed.

The Army Missile Command took control of the plant in July of 1962, and the facility became known as the Tar Heel Missile Plant in August of 1963.

Western Electric was a major employer in the area while this program was in full swing, with as many as three thousand people there at once, but the missile treaties with the Soviet Union in the early 1970s ended much of the work. After that, work in the plant declined, and eventually, Western Electric gave way to AT&T at that location.

Finally, in 1992, AT&T moved out of the facility, and it remained vacant until the early 2000s when the entire compound—then some twenty-six different buildings—was auctioned to a Burlington entrepreneur who plans to develop the property to new uses.

The old rayon plant survived for many years and had a productive career in the nation's military program. While many remember the Nike missile work done there, far less know of the airplane that was built there.

Some years ago, an effort was made to find one of the AT-21 gunners and return it to Burlington as a memorial to the area's unique role in World War II aviation. It was learned that some of the planes had been used at various civilian flying schools in the 1950s, but none has survived intact to the present era. However, the parts of one have been found and the plane is being rebuilt by a Texas airplane enthusiast.

North Carolina's Beauty Spot

It was in 1951 that Burlington became the beauty spot of North Carolina—at least for a week. Indeed, the appearance of the city was enhanced by the presence of the prettiest girls in the state—contestants in the Miss North Carolina Pageant—who were brought to the city by the Junior Chamber of Commerce, later known as the Jaycees.

Until 1951, the Miss North Carolina Beauty Pageant had been held in coastal cities of the state, in a beach atmosphere. Burlington Jaycees saw the pageant as a great opportunity to bring hundreds of people into the city for several days, helping the economy and giving Burlington some very positive statewide recognition. The Jaycees convinced pageant officials it was a good move and won the rights to the 1951 pageant.

They did it up in fine fashion. Burlington insurance executive Ed Hicklin was Jaycee president that year, and it was his duty to produce the state event.

The Alamance Hotel in downtown Burlington was pageant headquarters, and the auditorium of the Williams High School was the site of the event. It was the opening of that high school in 1951 that made it possible to have the pageant in Burlington. There was no other venue large enough to accommodate the crowd.

For three nights, North Carolina's prettiest and most talented young ladies performed on the stage in swimsuit, evening dress and talent competitions. The big attraction of the week was the reigning Miss America, Yolande Betbeze, an Alabama beauty who flew into Burlington Municipal Airport in an official State of Alabama DC-3 aircraft.

There were events all over Burlington that week related to the pageant. There was a day at City Park when all the girls rode the miniature train. And there was a huge parade in downtown Burlington: thousands lined the streets to see the girls ride by in what was described as the largest parade crowd in Burlington history.

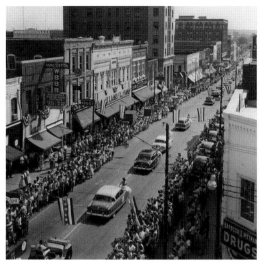

Miss North Carolina Pageant contestants rode down Main Street in Burlington by thousands of spectators. The pageants held in Burlington in 1951, 1954 and 1957 were the largest such events held in the county to that time.

Miss America led the way, and all the contestants followed in little Nash Rambler convertibles. The Rambler was the official pageant car, and the local dealership provided one for each of the contestants to use for the entire pageant week.

The 1951 pageant was a huge success. In fact, Miss America Pageant officials said it was the largest state pageant held in the history of the event. The success was in no small part due to the efforts of the sponsoring Jaycees.

Many of the members of that group were World War II veterans who had come out of service at the end of the war ready to take charge of things in their community back home. Some of them were war heroes, and they had the confidence and the energy to make things happen. Those men affected the community in many positive ways through their work in the Jaycees, and the beauty pageant was one of their most visible efforts.

Lu Long Ogburn of Smithfield was the winner of the pageant that year. On the Sunday morning after she was crowned, she and the other finalists appeared at Alamance Country Club to pose for members of the North Carolina Press Photographers Association. The photographers had a meeting here in conjunction with the pageant, and they photographed the girls in an association competition.

Lu Long went on to the Miss America Pageant in Atlantic City where she was first runner-up in the national event. Jaycee President Hicklin and Jim McCormick accompanied her to that pageant, and for the next year, Hicklin served as business manager for the state beauty queen.

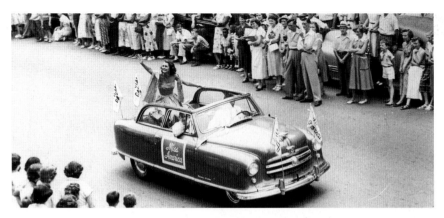

The star of the 1951 Miss North Carolina Pageant was Miss America, who rode at the head of the parade. Yolande Betbeze was from Alabama and served as a judge in the local pageant.

The success of the 1951 pageant made it an easy task to get the event back in Burlington in 1954 and 1957, and in both those years, the success was just as great. The Burlington pageant became a model for other state events across the nation, and representatives from other states came here to see just how the Jaycees did it.

The pageant in 1957 marked the end of the successful run in Burlington. The event moved on to other cities, much to the disappointment of the Jaycees and Burlington residents. The reason was not because of any lack of enthusiasm locally or because of any shortcomings in the ways the event was handled. The major factor in the decision not to come back to Burlington was air conditioning—or a lack thereof. The high school auditorium was not air-conditioned, and the pageant was always held in the middle of summer. Also, the auditorium could seat no more than 2,500 people. The pageant moved on to the bigger air-conditioned venues in the larger cities of the state. Nevertheless, they still used the blueprint developed in Burlington by the Jaycees.

Pageant news was not over in Alamance County, however. In 1963, a tall young lady from Graham, Jeanne Swanner, won the Miss Graham title. Jeanne stood six feet two inches tall, and she swept the Miss North Carolina title in Greensboro that summer. She was and still is the tallest girl to win the state beauty title.

The city of Graham was more than excited that Jeanne was Miss North Carolina. She is the only Graham girl to ever win the state title. Residents filled Court Square to greet her when she came home from the pageant.

Jeanne went on to Atlantic City and the Miss America Pageant, and four hundred of Graham's residents went along with her, many in a caravan of buses. Jeanne again

114

Jeanne Swanner of Graham was Miss North Carolina in 1963. Hundreds turned out to welcome her when she returned home from the pageant. *Photo courtesy of Jeanne Robertson.*

Jeanne Swanner Robertson, Miss North Carolina 1963, is now a nationally known humorist who is among the top speakers in the nation. *Photo courtesy of Jeanne Robertson.*

found herself as the tallest contestant ever in the national pageant, and she came home with the Miss Congeniality title—winning by the largest margin of votes ever.

An Auburn University graduate, Jeanne was a high school basketball coach for a few years but then found a new calling. She became a professional speaker, and for many years she has toured the United States, Canada and the Caribbean as a humorist, speaking at national conventions, corporate meetings and in some resort theaters. Jeanne became the first woman to win the Cavett Award, the top award of the National Speakers Association. She was also the first woman to win the Golden Gavel Award, the top award of Toastmasters International. In 2001 she was chosen as the North Carolinian of the Year by the North Carolina Press Association, and she was *Southern Lady* magazine's Southern Lady of the Year for 2005. Jeanne is also in the National Speakers Hall of Fame. She is on the road ten months out of the year, bringing laughter to her listeners as she laughs at herself, particularly her height and her part in the Miss North Carolina and Miss America Pageants.

Jeanne now resides in Burlington. She is married to Jerry Robertson, a former Duke University basketball player.

LBJ Comes to Elon

The flight of helicopters approached Elon College from the west, maneuvered into position and gently landed on the walled college lawn. As the engines stopped and the rotor blades stopped turning, Vice President Lyndon B. Johnson stepped from his helicopter to the sound of "The Yellow Rose of Texas" as played by the Southern Alamance High School Band. The vice-president greeted the sound with a huge smile.

This day, Thursday, March 8, 1962, will long be remembered as a big day in the history of Elon College. The vice-president came to Elon College for Founders Day activities at the Alamance County campus. He was the main speaker for the event and received an honorary doctor of laws degree during the program.

Little did anyone realize that day that Johnson would be president of the country following the assassination of John F. Kennedy before the end of his first term in office.

Several hundred people were on the campus for the arrival of the vice-president, and at mid-morning the flight of presidential helicopters appeared over the trees. The Johnson entourage had flown into the Greensboro-High Point Airport some twenty-five miles west, then took the helicopters to Elon College.

The presence of the vice-president attracted a number of other political personalities to the day's events. Both North Carolina senators, Sam Ervin and B. Everett Jordan, were present, as was Sixth District Congressman Horace Kornegay.

The bright, sunny day attracted several thousand people to the gymnasium for the address by Johnson; the crowd was estimated at a packed five thousand by the time the event began. Johnson spoke just one month after John Glenn had become the first American astronaut to orbit the earth. That mission in February brought new life to the U.S. space program that had previously been lagging behind the Soviet Union.

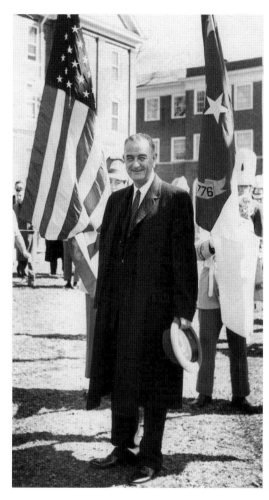

In 1962, Vice President Lyndon B. Johnson landed on the campus of Elon College in a helicopter and made the Founders Day address at the school. He also received an honorary degree.

Johnson was optimistic in his speech. He told the assembled group of Alamance County residents that the United States was pushing harder in its space efforts, and that by the end of the decade, the United States would send a three-man team to the moon and back.

In 1962 that was a concept that many Americans felt was no more than a dream. Glenn's mission had been a solo flight in a small Mercury capsule, a mission of three orbits around the globe. A mission to the moon within the next eight years seemed impossible. President Kennedy had pledged the nation to that moon mission, and Lyndon Johnson proved to be a good prophet on that day at Elon in 1962.

Much would happen to Johnson in the days ahead. In a short time he would find himself thrust into the presidency by the assassin's bullet that killed Kennedy in Dallas on November 22, 1963. He would serve out Kennedy's first term and then win election in his own right in 1964. His term, however, would be plagued by the war in Vietnam and protests over that war here at home. He did not seek reelection in 1968. Richard M. Nixon, a Republican, was in the White House that night in July of 1969 when Johnson's 1962 prophecy came true. Neil Armstrong set foot on the moon.

In 1962, however, all those things were far in the future. Elon College enjoyed its day with the vice-president, a day that was marked by political peace of sorts. Johnson was the staunchest of hard-line Democrats, but he came to Elon at the invitation of Dr. Earl Danieley, the Elon president who was one of the staunchest of the hard-line Alamance County Republicans.

In years to come, Gerald Ford would speak at Elon while still a Michigan congressman, and Jimmy Carter would come after his presidency was over. George H.W. Bush visited the university much later, after his term ended. The school, now Elon University, has played host to an array of world famous visitors, including former British Prime Minister Margaret Thatcher and a number of other former heads of state from Europe, Asia and Africa.

Ending a Water Shortage the Hard Way

There have been horrific hurricanes that have killed far more people than Hurricane Hazel, and Hazel is not even on the scale when storms are now compared for property damage. But in North Carolina, especially in the Piedmont area, Hurricane Hazel is the one that is remembered above all others. The storm ripped across the Piedmont on October 15, 1954, and left behind a path of heavy destruction from wind and flooding, not to mention the number of people killed.

In Alamance County, however, the memories of Hazel are not all bad. That storm ended what was perhaps the most severe water crisis in the history of the area. Burlington, Graham and surrounding communities were in severe straits as far as water was concerned. Graham was utterly desperate, dredging its reservoir, opening old wells and preparing to pump water from private ponds in the area.

This situation actually had its beginnings a year earlier when a severe drought hit the area during the summer months. Burlington made some emergency moves at that time, installing a pipeline to move water from nearby Haw River into the watershed of its main supply source, the Stony Creek reservoir. That little body of water had been formed in 1927 when a dam was erected there to provide Burlington with a permanent water supply.

Haw River was not the ideal source of water, as it was badly polluted. Little had been done in years past to protect it, and inflow from locations all along the river fouled its waters. It sometimes ran dark in color and had an unpleasant odor. The announcement that Burlington was going to pump water from the river was not welcomed with enthusiasm. But a crisis is a crisis.

The water supplies in the area bounced back during the winter months of 1953 and 1954, but when summer came in 1954, the rain stopped and the water levels

began to decline. As summer began to wane into September, the shortage threat again became major. At the same time, hurricane season was beginning to move into high gear. Hurricane Edna was threatening the East Coast of the United States, aimed at North Carolina's Cape Hatteras. On September 10, Edna passed off shore and went on its way north.

On September 16, it was announced that Graham had a ten-day supply of water, and it was beginning to receive water from Burlington's system. An old well at a Burlington Mills plant between the two towns was being reopened and put into use as a supplementary source. The water level at Burlington's Stony Creek reservoir was fifty-two inches below the top of the dam. That was getting low, but city officials did not see an emergency at that point.

By September 20, Graham was dredging its lake to provide more capacity for water storage, but without rain, there was no water to fill that extra capacity. On October 5, Graham announced a water emergency and implemented strict restrictions on water usage. A fine would be levied for any violations. And at the same time, Graham was looking to Mebane as a possible source of new water. Burlington had yet to implement restrictions but was asking for wise use of water. An October 8 story in the Burlington *Times-News* reported that communities all across North Carolina were looking into the possibility of bringing professional rainmakers to the state to try to solve the drought. Little did they know that Mother Nature was about to take care of the problem.

It was not until October 11 that much mention was made of Hurricane Hazel in the newspaper. On that date, it was reported that the first land area was in danger from the storm: Hazel was aiming at Haiti. She ripped into that island nation and moved over the tip of Cuba, according to a news report on October 12.

The next day, Burlington ordered its own water restrictions, and Graham was ready to tap private ponds for water. Hurricane Hazel was located 575 miles east of Miami, Florida, moving northwest toward the Carolinas.

On October 14, the water level in Burlington's Stony Creek Lake was ninety-nine inches below the top of the dam, and Graham started pumping from the private ponds.

During that night, however, the picture would change. In the early hours of October 15, Hurricane Hazel slammed ashore along the South Carolina–North Carolina border and headed toward Alamance County. The storm had left one hundred dead in Haiti, and it was cranking up to leave a path of destruction across the Carolinas.

The storm came through Alamance County and dumped 6.5 inches of rain in fourteen hours. Immediately, all water restrictions were lifted, and water was pouring over the dam at Stony Creek. The water shortage was over.

There was the darker side, however, as damage was widespread. Myrtle Beach and Wilmington were hit hard, and in Alamance a power company linesman named F.M. Crowder was killed making storm damage repairs. Utilities were out over a wide area, and in Graham, trees slammed into the Graham Presbyterian Church, causing heavy damage. Winds caused the roof of the Nicks Building on Court Square in Graham to collapse. That was the oldest business building in the county, and the top story of the four-floor building was blown away. It was only in recent years that the building was refurbished to its earlier state.

By October 17, Alamance County and North Carolina were beginning to get on with the task of rebuilding, and things were returning to normal as far as schools and business activities were concerned. An estimated fifteen people had died in North Carolina, including Mr. Crowder in Alamance. There was a lot of debris to be removed, and many homes and businesses had roof damage.

Although the water shortage was over, its memory was not forgotten. Burlington and the other Alamance County communities began to look for ways to prevent such crises in the future. A new city manager had been brought to Burlington in 1953 and was given the task of solving the city's water problems. J.D. Mackintosh Jr., working with a concerned city council, planned and built a new reservoir north of the city. That lake was named for one of the city council members who spearheaded the drive for more water, Allen B. Cammack. Its water could serve the city for an entire year without a drop of rain. Graham and Mebane also joined to build a new reservoir in the eastern part of the county.

Mackintosh and Cammack continued to push Burlington to seek new water, as the city's textile community needed huge amounts of water for finishing operations, and eventually Burlington built an even larger reservoir in the western part of the county. Burlington became recognized for having one of the best water supplies in the state when that new reservoir was opened. That latest water supply was named Lake Mackintosh, in honor of the city manager who became one of the leading experts on municipal water supplies in North Carolina during his tenure.

The abundance of water was testimony to the distance that the city had traveled since the early part of the twentieth century. When Burlington was in its infancy, one of the main sources of water was a well that sat right in the town's main

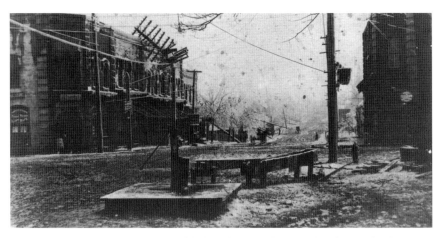

When Burlington was still young, it had little in the way of water. This photo, taken in a terrible ice storm in 1904, shows the water pump at the main intersection in town.

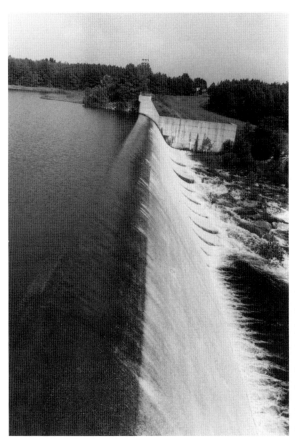

After Hurricane Hazel ended a water shortage in Burlington in 1954, the city built Lake Cammack north of town. It held enough water to serve the city for an entire year without a drop of rain.

122

intersection. That well was used by downtown businesses, but it was also a good watering point for the horses that passed along the streets.

A photo from 1904 shows that old city well at Main and Front Streets during yet another natural disaster to hit the community: a winter storm covered everything in sight under a solid sheet of ice. The water supply was frozen, but that was of little matter. The town was frozen over as well, so there was no one in town to need the water from that old well.

Presidential Visitors

It was in 1903 that Theodore Roosevelt first brought presidential politics to Burlington. He did so in his campaign for president that year, speaking from the back of his train at the Burlington depot. The old Rough Rider of Spanish-American War fame was seeking reelection to the office he had assumed in 1901 after the assassination of President William McKinley. Roosevelt made good in his 1903 bid and won election in his own right, serving until 1909.

It was a long time between campaign visits, however. Not again until 1948 would presidential candidates make Burlington a stop on the trail. That was a banner year, however, as three of the four major candidates campaigned in the city. Only President Harry Truman, the eventual winner, did not make the trip here.

New York Governor Thomas Dewey, the Republican candidate, made a campaign visit to Main Street, Burlington, stopping in front of Sellars Department Store to speak from the back seat of a convertible to the assembled crowd. He drew a big crowd and received a good welcome.

Another Main Street visitor that year was Senator Strom Thurmond of South Carolina. Senator Thurmond had led a group of Democrats in a split from the national party, forming the Dixiecrats. His party promoted states' rights and resistance to change in the segregated Southern states. Because of the local sentiment for his party's position, he too received a good welcome in Burlington.

The third candidate was not so well received. Henry Wallace, a former vice-president, held some socialist views and his was not a popular campaign. When he arrived in Burlington, he found out just how unpopular he was. He emerged from his car at the corner of Main and Front Streets, the city's main intersection. As he began to speak, he was heckled by the crowd that had gathered, and suddenly tomatoes and other vegetables began flying in his direction. Some hit

the target, so Wallace was whisked into his car and the campaign moved on to other North Carolina cities. In at least one other city, he found the same surprise waiting for him.

A Burlington movie theater operator, Frank Bruton, was also quite a good photographer, and he happened to be on hand with his camera that day and recorded Wallace's appearance and the ensuing attack. Bruton's photographs of that event appeared in the following issue of *Life* magazine.

Truman was the only one of the four candidates that year to bypass Burlington. Many felt he had written off the Southern states because of Thurmond's bid. In fact, most people in the nation seemed to believe that Dewey would win, due to the split in the Democratic Party. It was feared that Thurmond would take so many votes from Truman that Dewey would win easily.

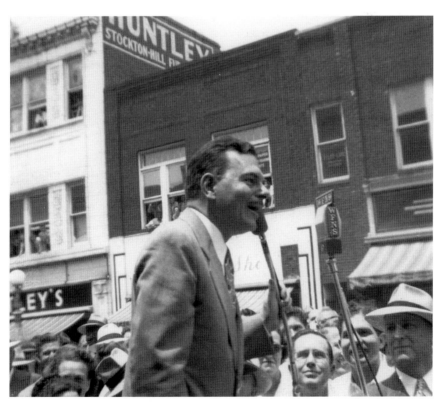

New York Governor Thomas E. Dewey was one of three presidential candidates to campaign in Burlington in 1948. He is shown here speaking on Main Street. Others who came were Senator Strom Thurmond and Henry Wallace.

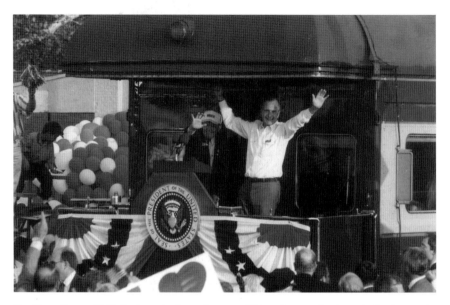

President George H.W. Bush spoke from the rear of his train near the depot in Burlington in his 1992 campaign for reelection. He spoke to a huge crowd here, but he was not successful in his bid.

That proved not to be the case. One of the great political photographs in history is that of Truman holding a Chicago newspaper declaring Dewey the winner. The newspaper had made its projection a bit early and went to press with a classic mistake.

There was another long lull in presidential politics in Alamance County after 1948. Lady Bird and Lynda Bird Johnson campaigned here in 1964, speaking from the back of a train in support of Lyndon Johnson's successful bid. It would not be until 1992 that more presidential candidates would come, and as it so happened, both the Republican and Democratic candidates appeared.

George H.W. Bush was seeking a second term in 1992, and he brought his campaign train to the Burlington depot again, a la Theodore Roosevelt. Bush spoke from the back platform of his railroad car to a huge crowd of spectators. Some of the downtown streets were closed off to traffic during his appearance, and city residents got a close-up view of presidential security. Metal detectors were set up for spectators, and during the speech everyone could see the armed marksmen above one of the nearby buildings as they watched the crowd.

In that same campaign, Bush's opponent, Bill Clinton, made a bus tour through North Carolina, and he made stops on the Elon College campus and in Graham near

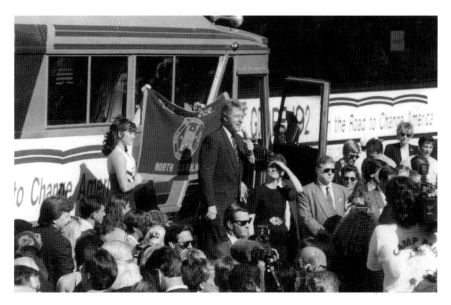

Arkansas Governor Bill Clinton and his running mate, Senator Al Gore, spoke on the campus of Elon College in the 1992 campaign. They also spoke in Graham in a bus swing across North Carolina.

the courthouse. With Clinton was his running mate, Al Gore, and both candidates had their wives with them. At both locations, the turnout was huge and the crowds enthusiastic. Clinton, of course, won that election and served eight years.

President Bush would later visit Elon as well, this time as an elder statesman who addressed a campus convocation. Former President Jimmy Carter visited Elon after he left office, and President Gerald Ford was there while he was still a representative from Michigan. Vice President Lyndon B. Johnson spoke on campus in 1962, over a year before he became president due to the assassination of President Kennedy.

Since 1992, the presidential campaign trail has not included Burlington or Alamance County.

About the Author

Don Bolden is a native of Burlington, North Carolina, and has lived his entire life there, except for the four years he spent at the University of North Carolina. He is editor emeritus of the *Times-News* in Burlington, where he spent his entire career of fifty-one years. For many of those years he wrote items related to the history of Burlington and Alamance County and has authored four previous books on the history of the area. In retirement, he continues to write a weekly column for the *Times-News*.